Living Witness

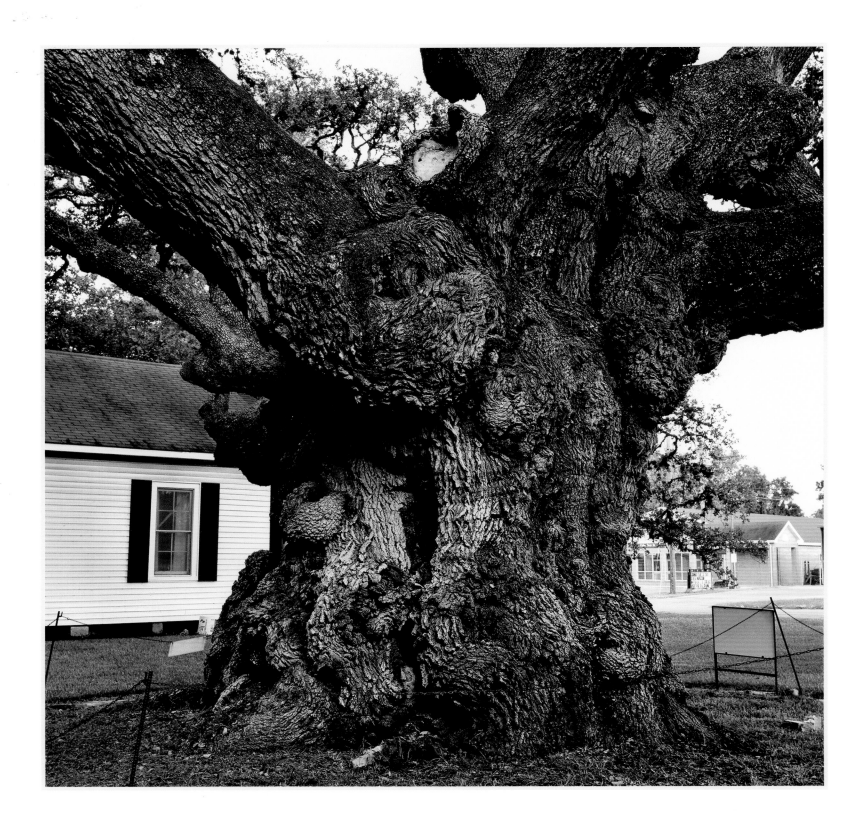

Living Witness

HISTORIC TREES OF TEXAS

RALPH YZNAGA

Foreword by Damon Waitt

TEXAS A&M UNIVERSITY PRESS

COLLEGE STATION

To Cecily —
Wishing you
warm memories
of Texas.
Much love —
Sue

Sue —
Thank for
keeping out
heritage alive!

Copyright © 2012 by Ralph Yznaga
Manufactured in China by Everbest Printing Co.,
through FCI Print Group
First edition
This paper meets the requirements of ANSI/NISO Z39.48-H-1992
(Permanence of Paper).
Binding materials have been chosen for durability.

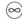

Library of Congress Cataloging-in-Publication Data

Yznaga, Ralph, 1959-
Living witness : historic trees of Texas / Ralph Yznaga ; foreword by Damon Waitt.—1st ed.
p. cm.
Includes index.
ISBN 978–1-60344–576–4 (flexibound : alk. paper)—
ISBN 978–1-60344–767–6 (ebook format/ebook—c)
1. Historic trees—Texas—Pictorial works. 2. Historic trees—Texas—Guidebooks.
3. Texas—History, Local. I. Title.
F387.Y96 2012
976.4—dc23

2011039676

To the people of Texas

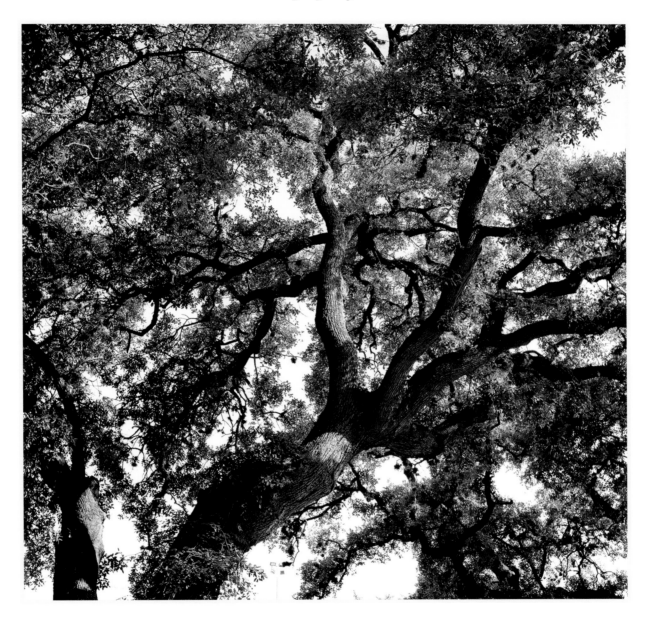

Contents

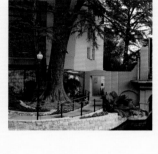

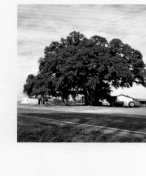

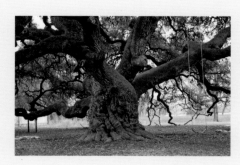

Foreword

Ralph Yznaga's *Living Witness: Historic Trees of Texas* was inspired by the Texas Forest Service's book *Famous Trees of Texas,* published in 1970, and now replaced by their website of the same name. Appropriately titled, these famous and historic trees have stood the test of time and still stand as witnesses to the events that make Texas history come alive for many people.

By virtue of their size and longevity, trees are often identified with historic places or events. Thanks to books like *Famous Trees of Texas* and, now, *Living Witness,* the popularity of these trees and interest in preserving them is on the rise. From the Heart O' Texas Oak, which marks the exact center of the state, to San Antonio's Ben Milam Cypress, which housed a Mexican sniper in the battle of San Antonio, these trees have fascinating stories to tell that span both space and time.

One of Texas' most well-known historic trees, Austin's 500-year-old Treaty Oak, is the sole survivor of a group of oaks known as the council oaks under which Stephen F. Austin was purported to have signed a boundary treaty with Native Americans. In 1927, the Treaty Oak was voted by the conservation organization American Forests to be the most perfect specimen of an oak tree in the United States. In 1989, the Treaty Oak was again in the national spotlight when, spurned by his lover, a man attempted to poison the tree to keep the woman he loved from the arms of another. The man served ten years in prison, and experts managed to save about one-third of the tree. Today, the Treaty Oak lives on, as do its offspring in the numerous botanical collections throughout Texas.

One such collection, the Lady Bird Johnson Wildflower Center's Mollie Steves Zachry Texas Arboretum, features a Hall of Texas Heroes where Texas' past will come alive through the propagation of historically significant trees. This collection helps conserve the heritage of culturally significant trees and provides a tangible and living connection to historic events, persons, and places. While the Wildflower Center pays homage to these historic trees by preserving their germplasm for generations to come, Yznaga pays homage to the originals in *Living Witness.* Maybe its time you paid a visit . . . to a tree.

—DAMON E. WAITT,
 Senior Director and Botanist
 Lady Bird Johnson Wildflower Center

Preface

The name *Texas* evokes dusty Spanish missions, cowboys resting beneath a sea of stars, and battles with Comanches. The place has a strong aura and seemingly myriad legends, based in both reality and myth. Its mystique is partly due to the great variety of people who have called this land home and, just as significantly, to the nature of the land itself. One impressive attribute of this land is the bounty of imposing trees. Hollywood may have contributed to the popular misperception that Texas is treeless, but even in the starkest landscapes, like the plains of West Texas, trees are often the only identifiable feature on the landscape. Elsewhere across the state, tall elms, rustling cottonwoods, majestic live oaks, and stately pecans dignify a landscape of lonely deserts, arid mountains, whispering marshes, long beaches, and impenetrable forests.

Texas' trees have always been respected for the comfort they provide. Native Americans used them as landmarks, meeting places, and protection from harsh weather. The Spanish, French, and Mexicans established settlements among them, using their wood for missions and forts.

Later, their wide boughs supported the homes and marked the homesteads of Anglo settlers. During conflicts settlers used them as mustering places, scouting nests, and, in one fateful case, a sniper's perch. In peacetime, churches and courts held services and convened sessions beneath them, and their accommodating limbs were often the site of frontier justice.

Five hundred years after Europeans first arrived in the Americas, some of the trees that were seedlings or saplings then remain among us as silent witnesses to or participants in history. Today it seems remarkable that you can stand under the same tree where Sam Houston gathered his small army on its journey to San Jacinto. For me, learning the stories of these great trees and the lives of the people connected to them has been an exciting journey of discovery. I hope you enjoy learning their stories as much as I have.

With all the physical changes we are imposing on our land, it is more important than ever that we protect these trees—they not only support life but are also our last living witnesses to a unique story.

Acknowledgments

At GSD&M: Roy Spence, Steve Gurasich, Duff Stewart, Judy Trabulsi, Brent Ladd, Ray Longoria, Steve Miller, Richard Apel, Scott Moore, David Rockwood, Carlotta Stankiewicz, Ronnie Steck, Karen White, Candace Davis, Anne Rix Sifuentez, Jennifer Warren, Mark Ray, Neyssan Moshref, Sam Bennett, John McGrath, Karen Boykin, Oscar Llarena, Kelly Berkey, Mary Ellen Resnick, anyone I forgot to mention, and special thanks to Liz Hamel for her wonderful ideas and logo design.

Also, Luci Miller and the team at Miller Blueprint, and Adam Vorhees for his photography advice and prints.

At the Lady Bird Johnson Wildflower Center: Joseph Hammer, Damon Waitt, and the rest of the amazing people who have created this amazing place.

At Texas A&M University Press: Shannon Davies, Patricia Clabaugh, Mary Ann Jacob, Kevin Grossman, Gayla Christiansen, Caitlin Churchill, Holli Estridge, and Maureen Bemko.

In my family: My wife, Jerri Ann for her endless ideas and good judgment; my daughters, Juliet and Josephine, for their inspiration and photos, my mother, Connie, and my faithful traveling companion, Mutti.

Living Witness

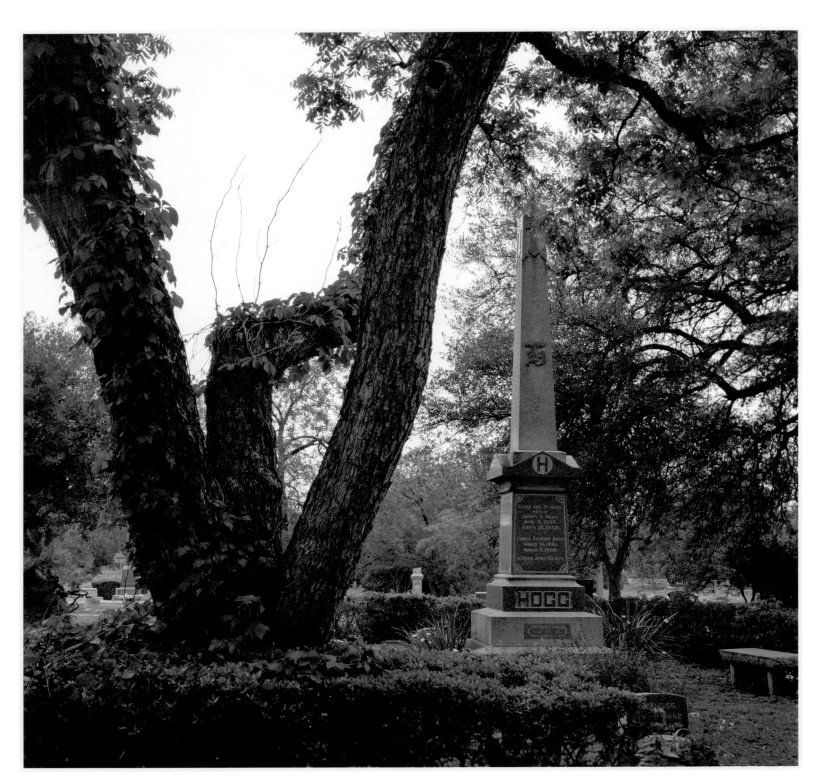

THE HOGG PECAN

AUSTIN

🌿 A governor's final request: plant trees at my grave and share the fruit with the people of our state.

"Let my children plant at the head of my grave a pecan tree and at my feet an old-fashioned walnut tree. And when these trees shall bear, let the pecans and the walnuts be given out among the plain people so that they may plant them and make Texas a land of trees." When Governor James Stephen Hogg died in 1906, the state honored this deathbed request and planted the trees. When the trees matured, the Department of Horticulture at Texas A&M distributed the nuts to groups around the state. One of the original pecan trees planted then continues to gracefully stand watch over the governor's resting place. Many noted individuals, both living trees and entombed Texans, occupy the beautiful cemetery.

From the Interstate 35 local lanes in Austin, take exit 235A and follow the access road (turning left at Fifteenth if coming from the north) until you are northbound on the access road, just north of Fifteenth Street. Turn east (right) onto Sixteenth Street and drive a short distance to the main entrance of Oakwood Cemetery at Sixteenth and Navasota streets. Enter the cemetery grounds and go to the fifth driveway on the left, where you turn and proceed a tenth of a mile to the Hogg burial plot on the right.

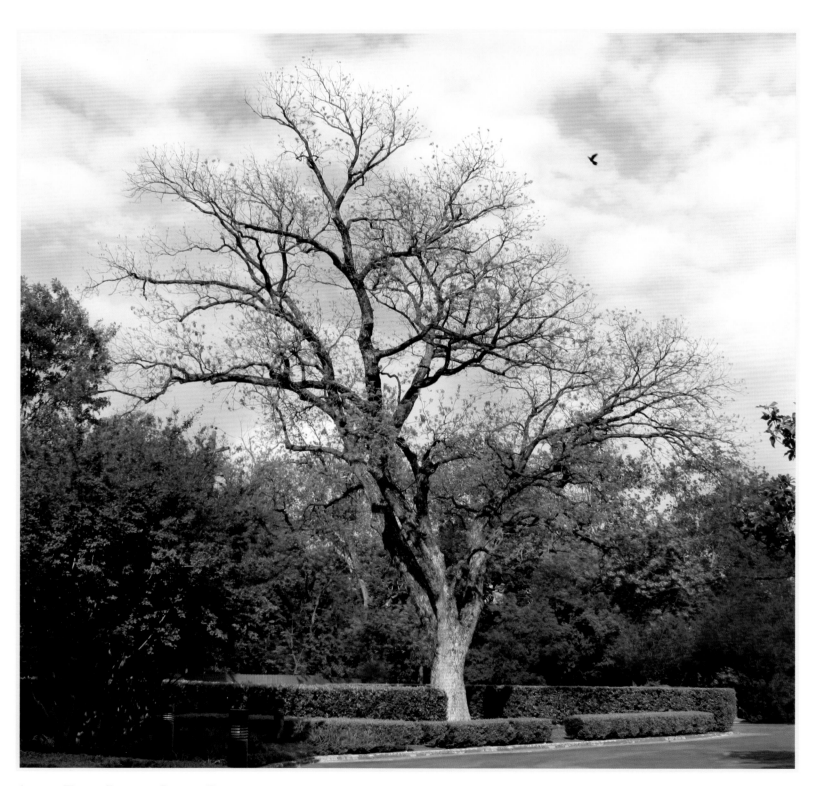

The Lone Star Pecan

AUSTIN

✍ After surviving tornadoes, freezes, and droughts, it earned the right to survive a parking garage.

When Roy Spence, chairman and founder of GSD&M, an Austin-based advertising agency, decided to build a parking garage, he was told that the beloved pecan tree behind the building would have to be cut down. Undaunted, he decided to have the tree relocated a distance of forty feet, at great cost. The towering tree holds the title of being the largest tree ever moved in the state, proving once again that things, even landscaping, are truly bigger in Texas.

From the local lanes of Interstate 35, take one of the downtown exits and continue on the access road to Sixth Street. Head west on Sixth Street, cross Congress Avenue, and continue seven blocks to West Avenue, turning right on West. The tree is behind the GSD&M office building at 828 West Sixth Street.

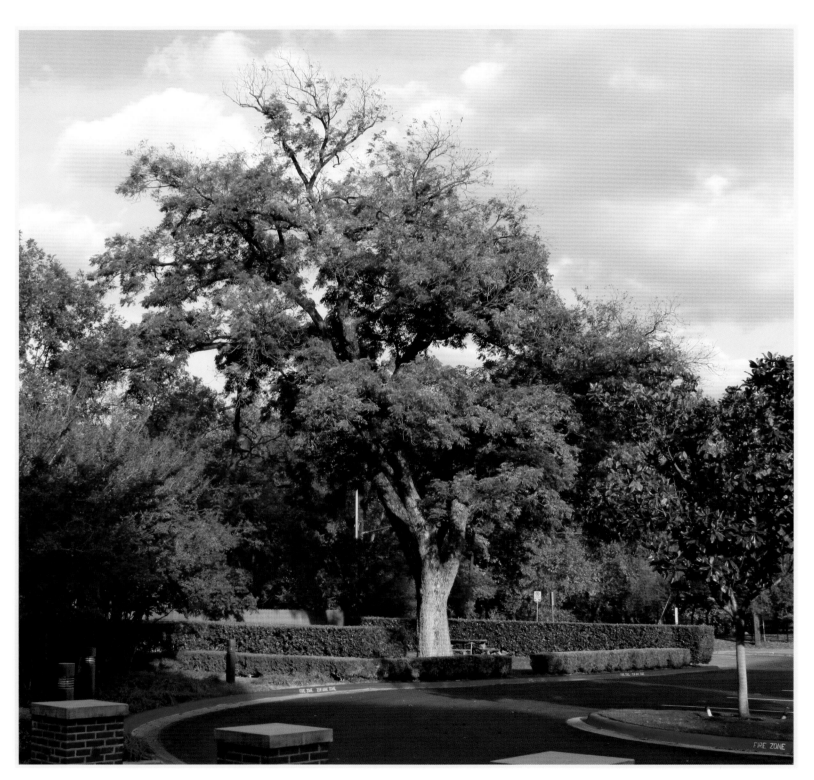

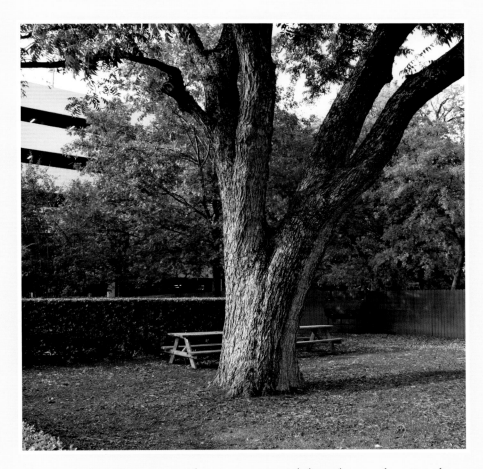

The Lone Star Pecan presides over two park benches and a giant bar-
becue pit. Office parties are often held beneath the expansive tree.
The greenbelt of nearby Shoal Creek ensures that the pecans that fall
end up feeding squirrels, birds, and other city-dwelling animals.

POSTSCRIPT: Unfortunately, the Lone Star Pecan succumbed to dis-
ease and drought in September of 2011, and had to be cut down. Much
of the wood was used to help rebuild homes destroyed in the Bastrop
County wildfire.

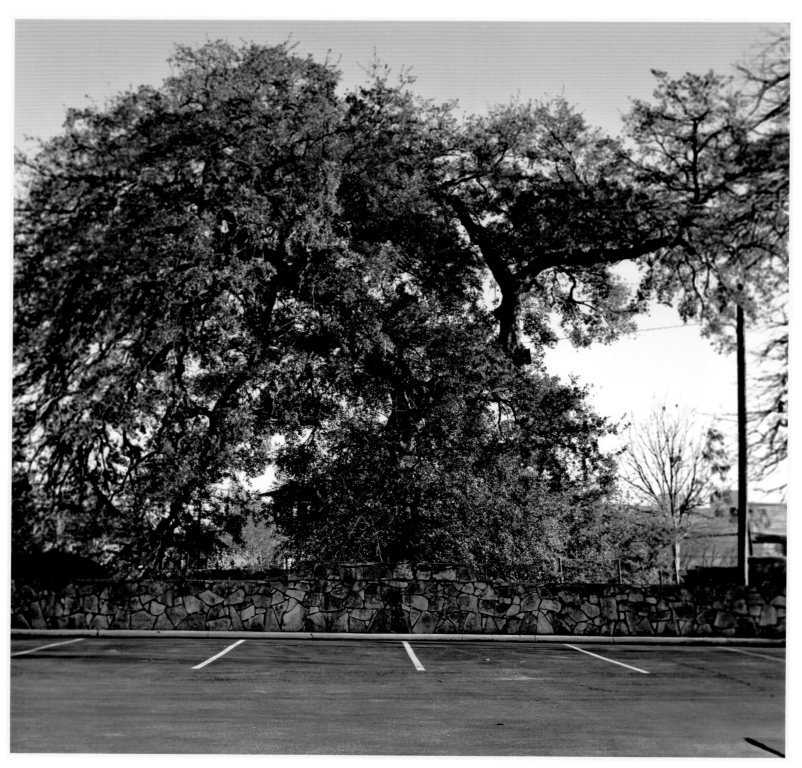

THE TREATY OAK

AUSTIN

🌿 People gathered here to find common cause, but today, keeping the Treaty Oak alive is the cause.

One of the most famous trees in Texas, the mighty Treaty Oak has had its lease on life extended many times. Once voted the "most perfect specimen of an oak tree in the United States," the tree is the last of a group of twelve trees growing at a spot where Texas tribes made treaties among themselves. Stephen F. Austin is believed to have negotiated one of the earliest treaties between Texas settlers and Native Americans under the branches of this tree. Intriguingly, the Indians believed drinking tea brewed from its leaves could make someone fall hopelessly in love. It must work on some level, as the tree is one of the beloved icons of Central Texas.

From the local lanes of Interstate 35, take one of the downtown exits and continue on the access road to Sixth Street. Head west on Sixth Street, crossing first Congress Avenue and then North Lamar Boulevard. A block after Lamar, turn left on Baylor Street. Treaty Oak Park is on the east side of Baylor Street, before you reach Fifth Street.

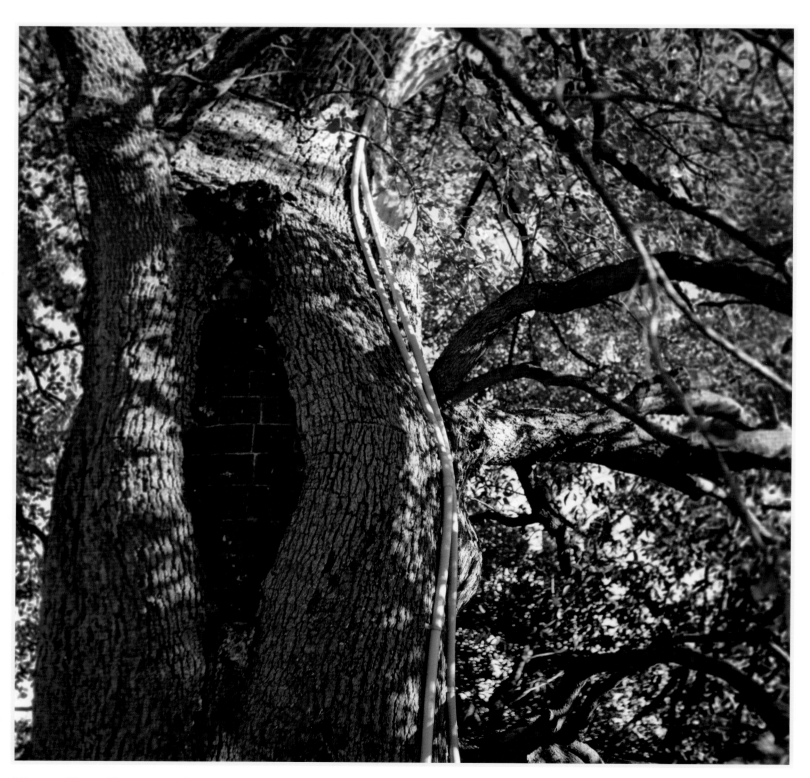

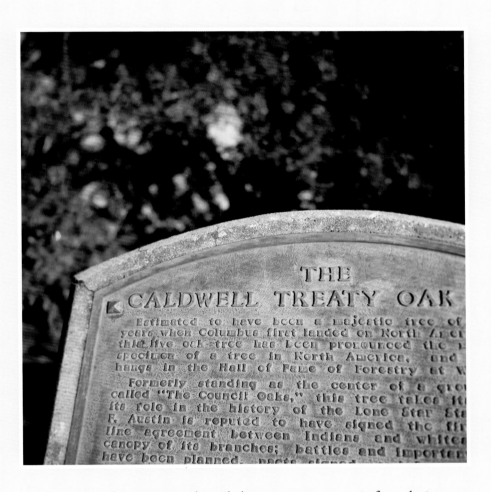

In the 1930s the state purchased the tree to prevent it from being cut down. Victim of a horrific herbicide poisoning in 1989, the tree has survived a lengthy battle for existence, thanks to the efforts of concerned people across the state. Quite recently, the efforts have finally been declared a complete success. A small park surrounds the grounds, and visitors to Austin often stop to pay their respects to the indomitable spirit of this tree.

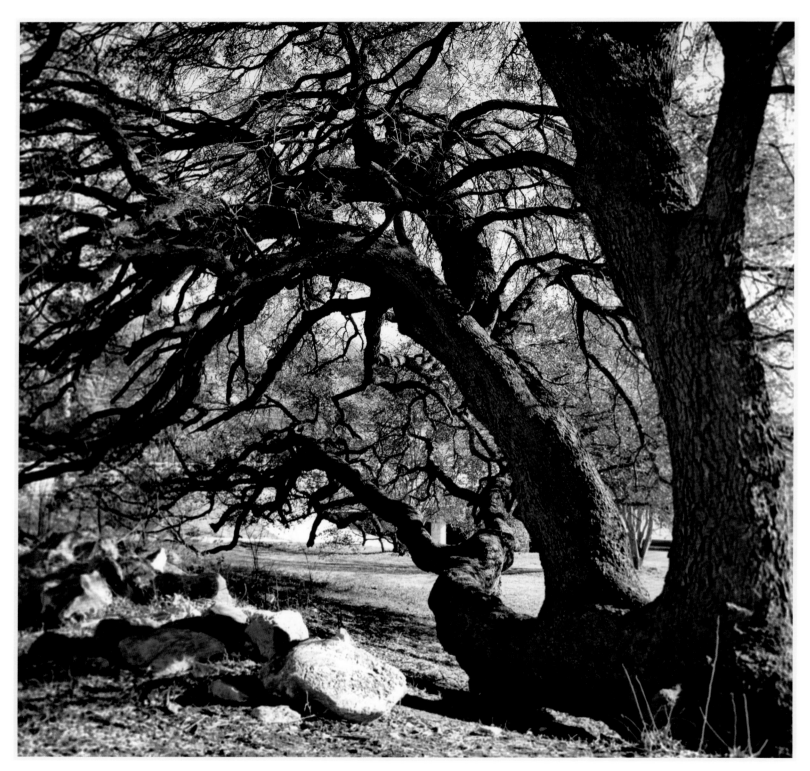

The Indian Marker Tree

BURNET

Long ago, the Comanches tied down these branches to mark a campsite, but today, those branches point back in time.

Close to the center of Burnet, next door to a motel that has been converted into a retirement community facility, stands one of the most unusual-looking trees in the state. The arms of this amazing tree reach out hundreds of feet, mostly sideways. Long ago, the Comanches of Central Texas marked favorable campsites by tying down saplings. The plentiful fresh water, shade, and numerous pecan trees make it is easy to see why the People, as the Comanches called themselves, so often chose to camp in this spot.

Burnet lies about thirty-five miles west of Interstate 35 and Georgetown on State Route 29. On State Route 29 (Polk Street) in downtown Burnet, head west until you cross Hamilton Creek (and Polk Street becomes Buchanan Drive). The tree is on the left, between the creek and a large restaurant/inn that faces Buchanan and South Hamilton Creek Drives.

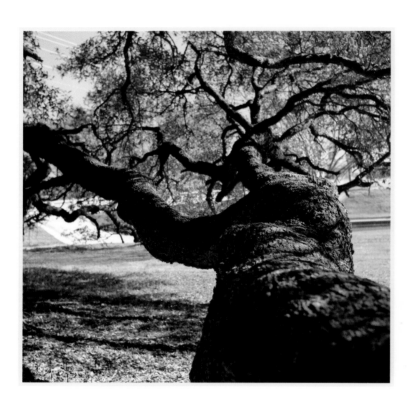 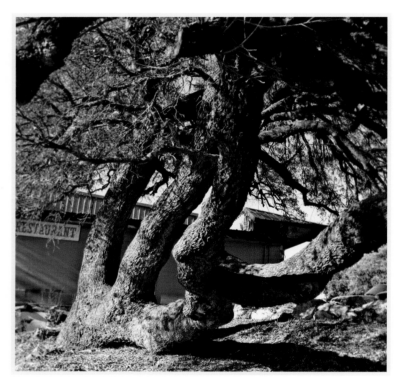

According to the early settlers, the plains nomads would silently appear, set up camp, enjoy the cool waters for a few days, and depart just as un-remarkably. Perhaps the tree marked a direction for other members of the tribe to follow. Like the free-riding Comanches themselves, the true meaning is lost to us. A pleasant park surrounds the tree, testimony to the good judgment of the Lords of the Southern Plains.

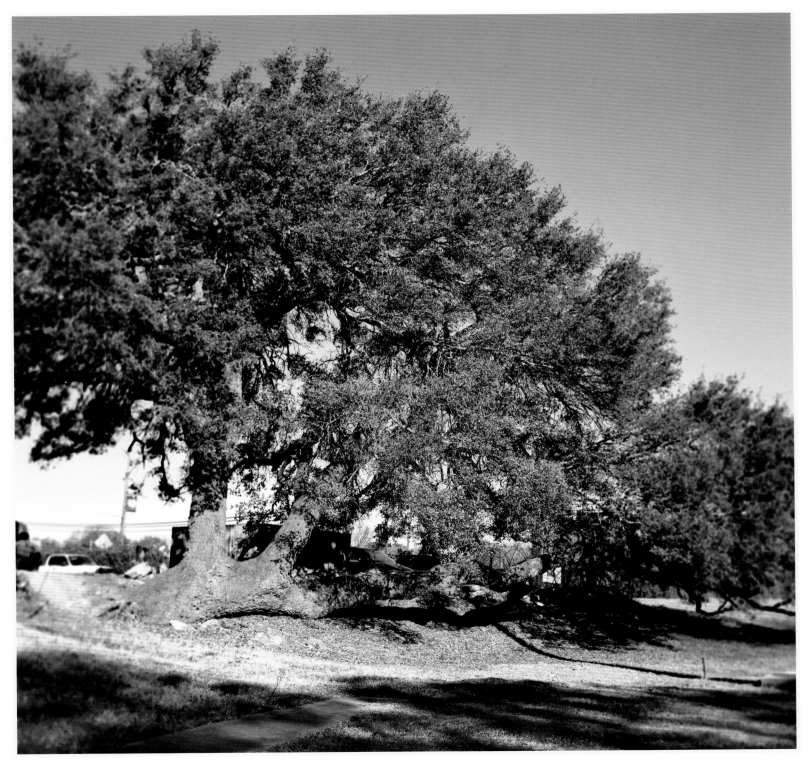

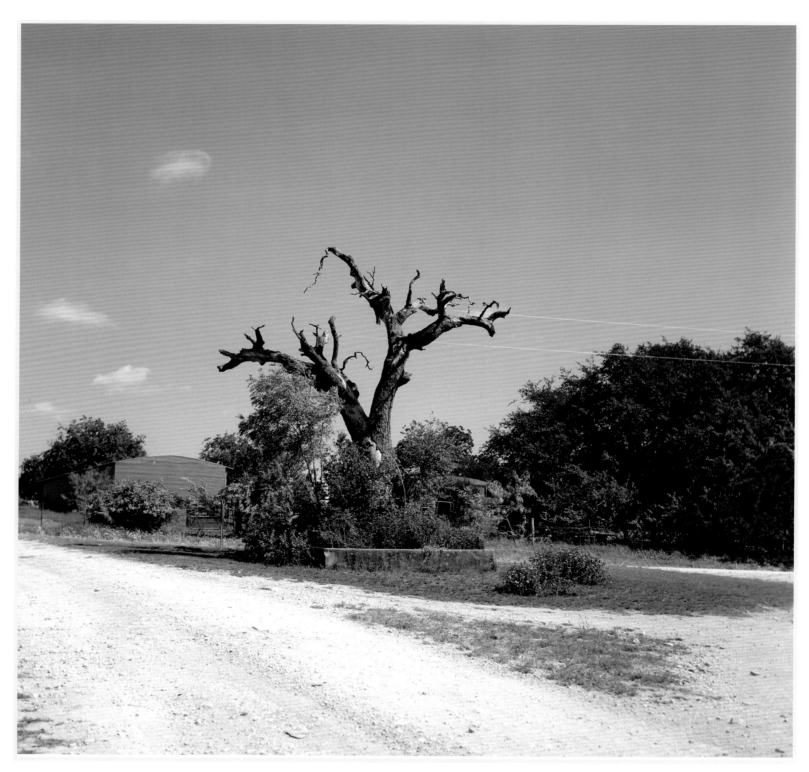

THE CENTER OAK

CENTER CITY

❧ Once considered the very center of Texas, the tree has expired but the legend lives on.

Center City was never really the center of the state, nor was it a city. Still, legends carry authority in Texas, and today, the ruined oak tree located there is still famous for being the very center point of the state. All that remains of the town is, fittingly, a cemetery and the dogged beliefs of a few locals. Regardless, the scenic Hill Country drive makes a visit to the former town and tree worth the trip.

To reach the site from the intersection of US Highways 281 and 84 on the Hamilton-Coryell county line (at the town of Evant), head west on US 84 about nine miles, passing through Star and Center City. Shortly after passing Center City, turn left (south) on County Road 332 and about a hundred yards down, just before the cemetery, the Center Oak sits inside a triangular island formed by three roadways.

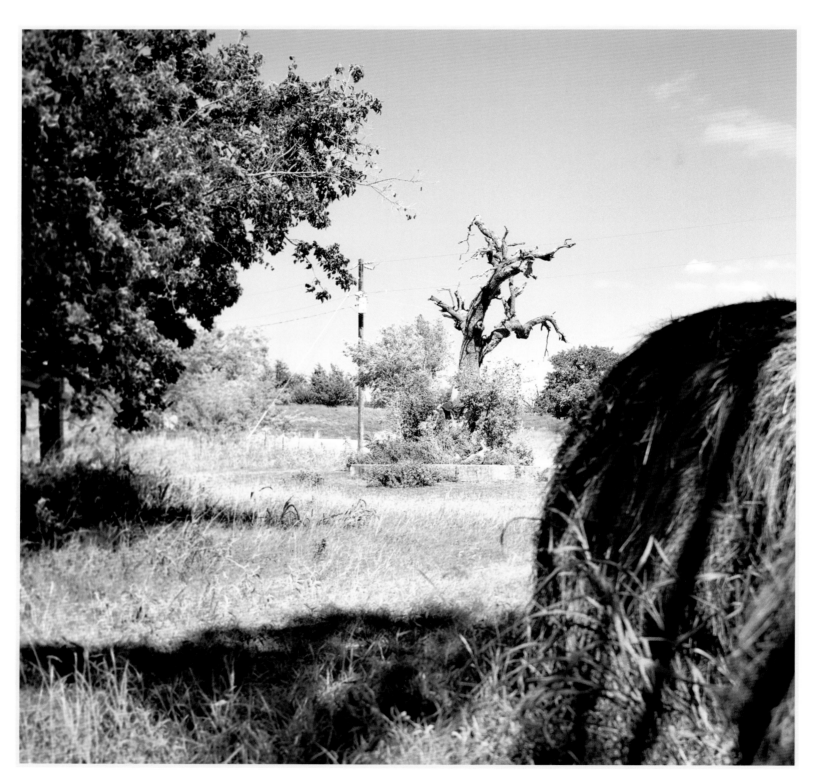

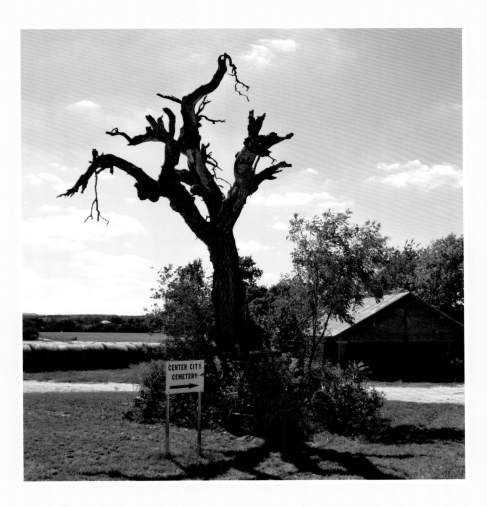

The withered oak tree is no longer alive; only the trunk remains. Apparently, the tree was struck by lightning a number of years ago, but a cursory examination of the trunk reveals ample evidence of wood ants.

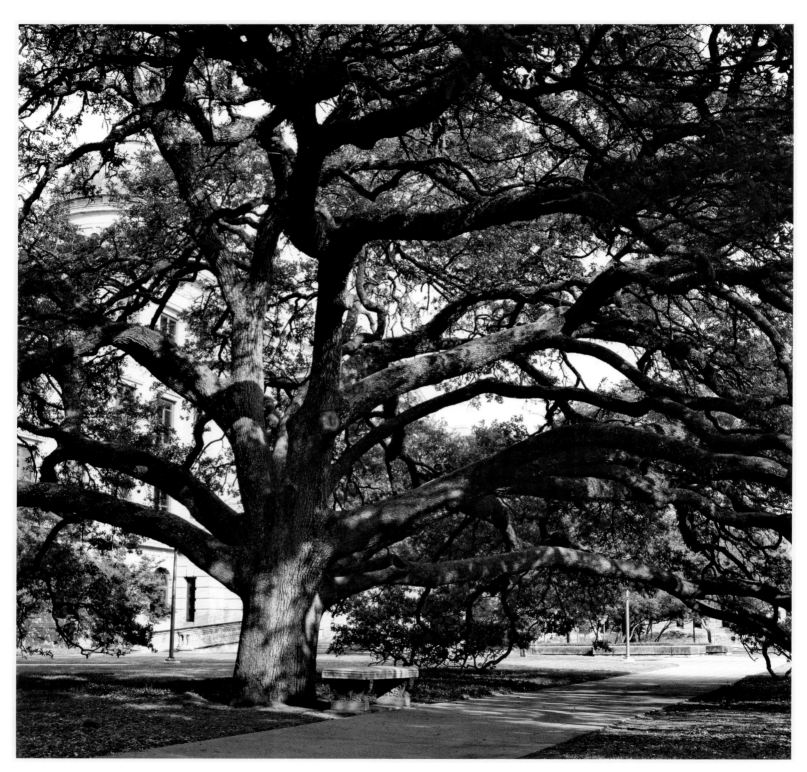

THE CENTURY TREE

COLLEGE STATION

🍃 In a place where traditions hold strength, this revered tree has the power to unite two people for life.

Few places honor their traditions with more reverence than Texas A&M University. One such story concerns the legend of the Century Tree. One of the first trees planted on campus, the venerable oak occupies a large area across from the stately Academic Building and is considered the most romantic spot on campus. No one knows when or how the tradition started, but when you walk under the tree with someone special, it is believed you will spend your life together. Countless proposals and weddings have taken place beneath the tree. Members of the Corps of Cadets accompany their proposals with a military saber arch from fellow cadets. Special friendships can also be cemented for life beneath the tree, but woe to the hapless soul who passes beneath the tree alone—they are destined to live a solitary life.

From the western entrance to the Texas A&M University campus on Old Main Drive across from the railroad tracks, head into campus on Old Main, cross the Military Walk, and you will be facing the Academic Building. The Century Tree will be on your left. For complete information about visiting and parking at Texas A&M University, go to www.maps.tamu.edu.

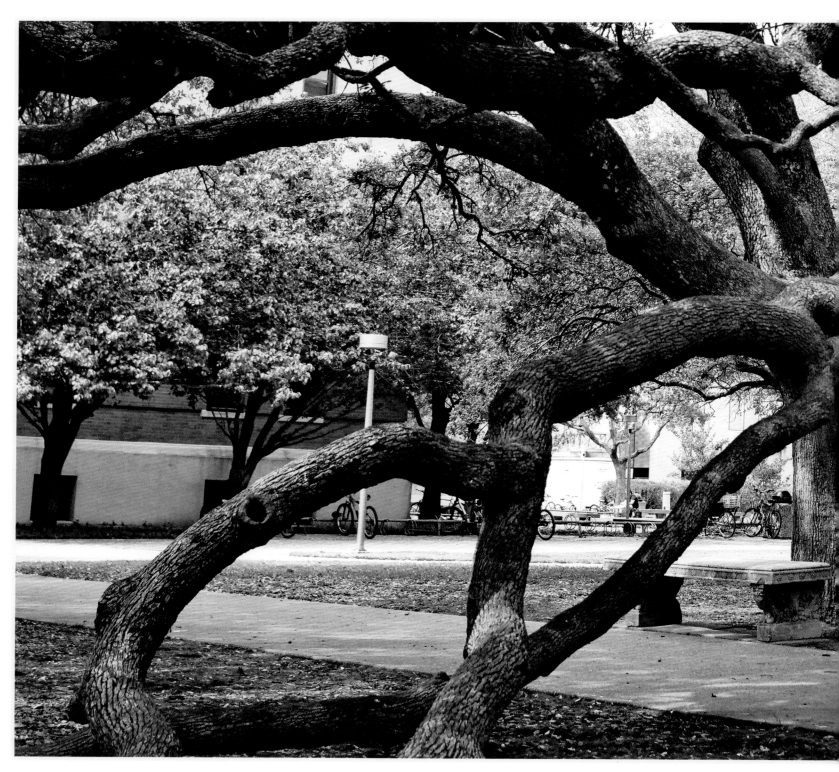

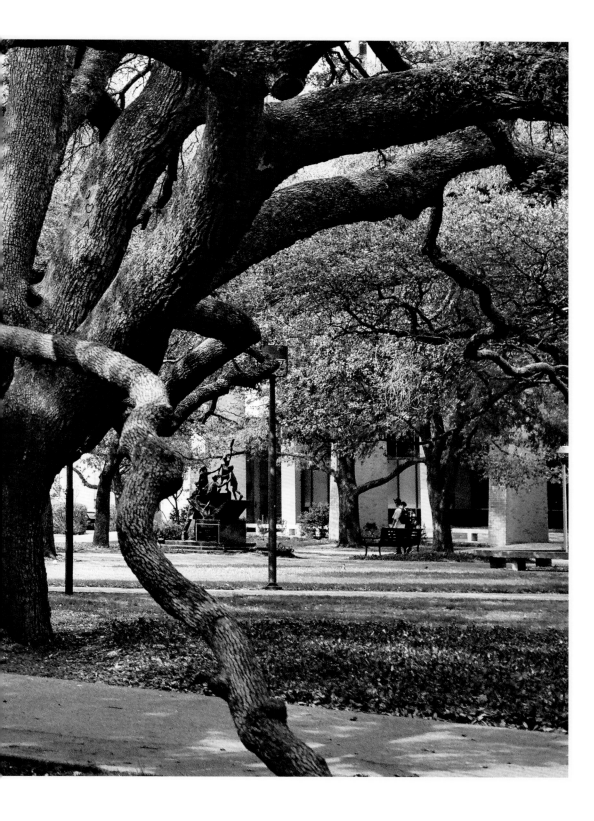

Surrounded by some of the most picturesque buildings on campus, the grass alongside the broad canopy is a favorite spot for students to meet and relax. Of course, the youthful picnickers carefully avoid sitting directly beneath the spread. Former Aggies, often accompanied by small children, can also be seen taking family photos on the benches beneath the oak. Infrequently, you can observe someone who apparently disregards the legend and will blithely walk alone beneath the tree. Still, as they make their way beneath the boughs, their pace seems just a little quicker than normal. Legends, while not always honored, are rarely ignored.

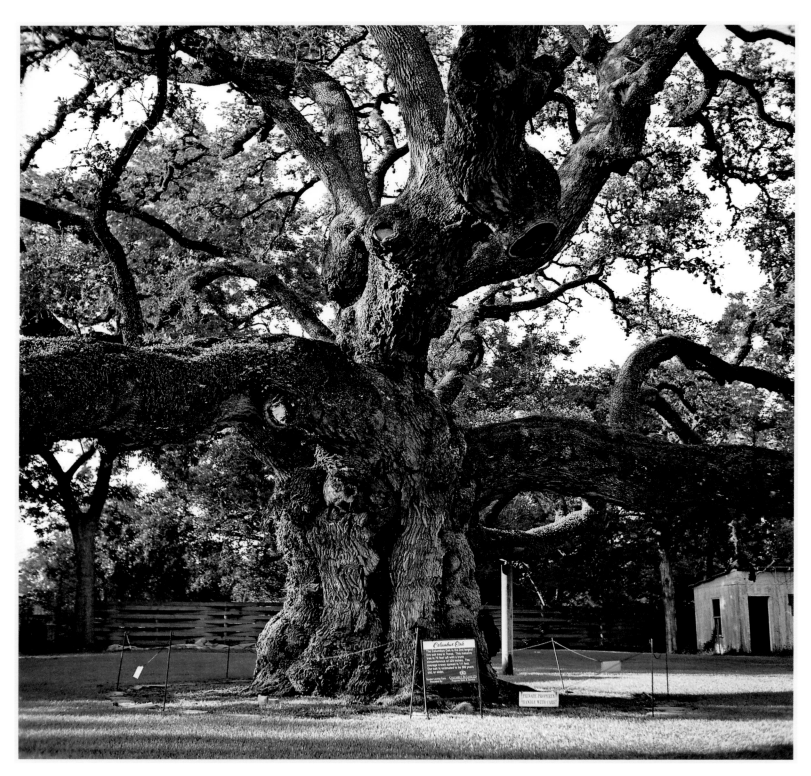

THE COLUMBUS OAK

COLUMBUS

🌿 If it's the second largest tree in the state, don't tell the people who live here.

The Columbus Oak is officially the second largest tree in Texas. When I stopped in a local diner for directions, I learned that people here believe their tree is actually the largest. They contend that the largest tree actually consists of two intertwined trunks and thus should relinquish the title. Whatever its rank among Texas trees, the Columbus Oak is an awe-inspiring sight.

To view the Columbus Oak, take State Route 71 or Interstate 10 to Columbus and exit on Business Route 71 (South Fannin Street). Follow Fannin/BR 71 to its intersection with Walnut Street (US Highway 90). Turn west on Walnut. The tree is on Walnut Street between Rampart Street and Veterans Drive (old Texas Highway 90) near the Columbus City Cemetery.

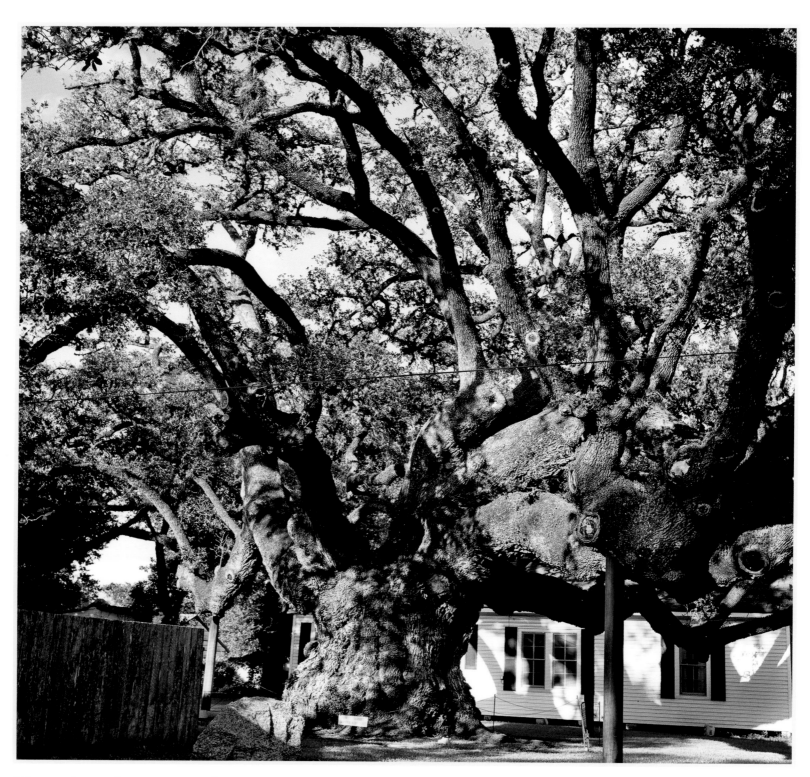

The trunk of this vast tree is impossibly gnarled, providing evidence of its tremendous age. Picture a tree that stretches the length of a New York City block. The next time you are on Interstate 10 in the vicinity of Columbus, take a little time and go see it. Considering that conservative estimates place its age at more than five hundred years, chances are good it will be there waiting for you.

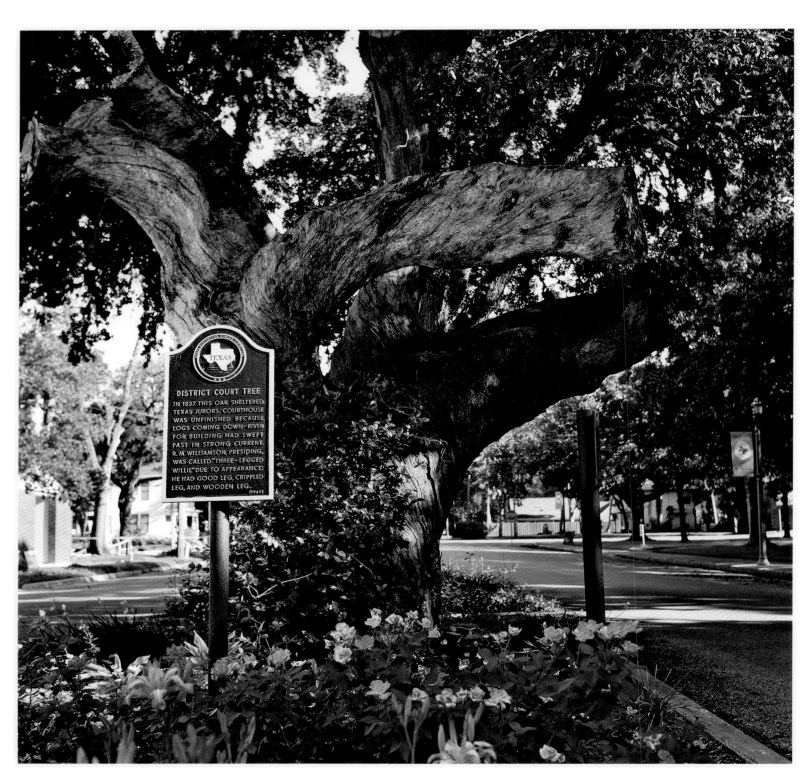

DISTRICT COURT TREE
IN 1837 THIS OAK SHELTERED
TEXAS JURORS. COURTHOUSE
WAS UNFINISHED, BECAUSE
LOGS COMING DOWN-RIVER
FOR BUILDING HAD SWEPT
PAST IN STRONG CURRENT.
R. M. WILLIAMSON, PRESIDING,
WAS CALLED "THREE-LEGGED
WILLIE" DUE TO APPEARANCE:
HE HAD GOOD LEG, CRIPPLED
LEG, AND WOODEN LEG.
(1969)

THE COLUMBUS COURT OAK

COLUMBUS

🙣 The tree whose broad limbs provided an early court for a new country.

When Mexican forces under General Santa Anna were moving eastward through Texas, fleeing settlers burned the original Columbus courthouse so that it wouldn't fall into enemy hands. After the war, court sessions reconvened under a large oak tree until a new courthouse could be built. The tree soon acquired the simple name, the "Court Oak."

To view the remains of the Court Oak, travel to Columbus by State Route 71 or Interstate 10 and exit at Business Route 71 (South Fannin Street). Continue on Fannin/BR 71 to US Highway 90 (Walnut Street) and turn east. Go six blocks, to Travis Street. The tree is located in the middle of Travis Street, just to the east of the Colorado County Courthouse.

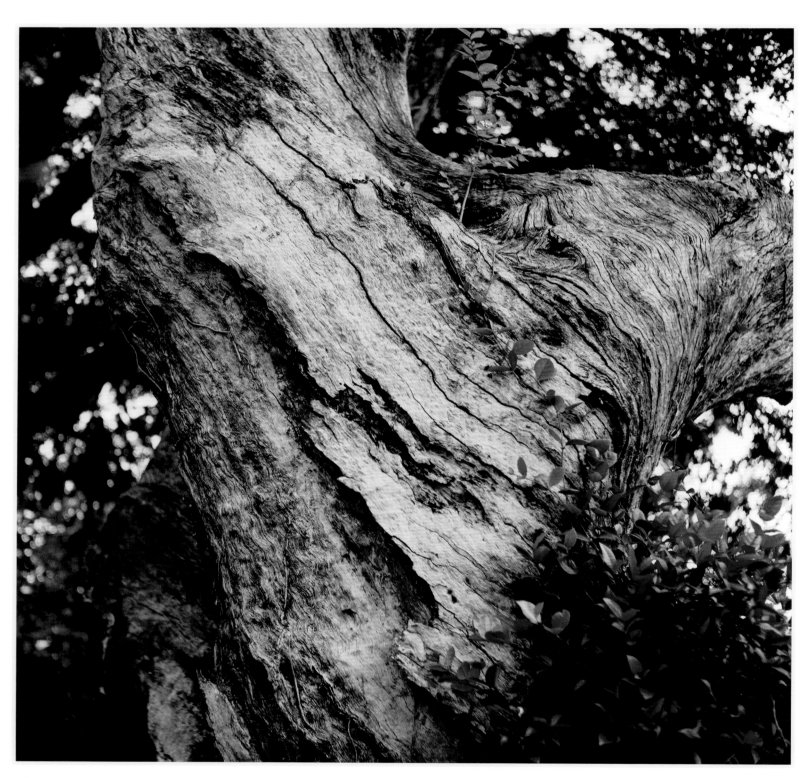

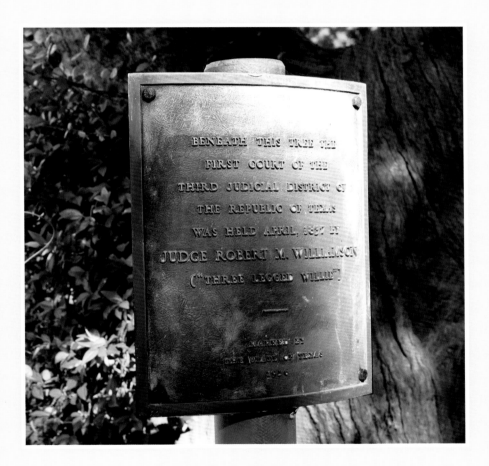

The textures and colors of the antique trunk have the look of an old painting. Standing here, you can picture early settlers holding court beneath the broad limbs. The carefully tended flowerbed at the base of the tree demonstrates the townspeople's pride in their history.

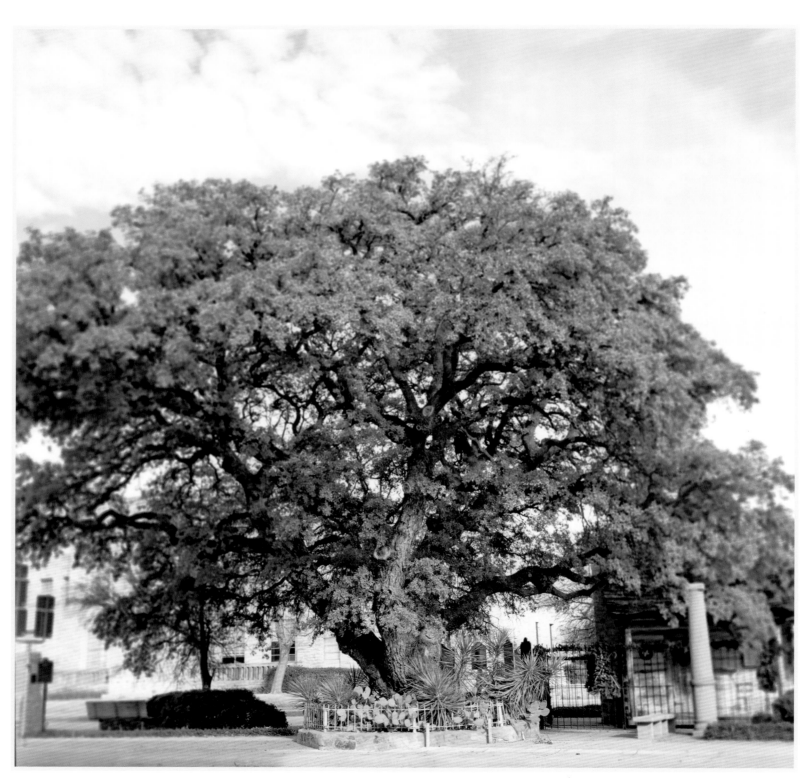

THE FLEMING OAK

COMANCHE

🖎 Because it helped save his life, he would punish with death anyone who removed it.

When Martin Fleming arrived in Texas in 1854, Comanches set upon his family. He survived the ordeal by huddling in the space between two trunks of a large tree. Soon, settlers developed the area enough to establish a town named Comanche, with the tree located in a corner of the town square. Years later, around 1910, workers attempted to cut down the tree to further develop their town. A much older Martin Fleming suggested that anyone cutting his tree would soon be receiving a blast from his "number 10." Since it was unclear whether he was referring to his size 10 boots or 10-gauge shotgun, the workers wisely departed. The tree, needless to say, is still standing.

Comanche is located in the county of the same name, southwest of Fort Worth on the Texas Forts Trail. The Fleming Oak is on the southwest corner of the courthouse square at Central Avenue (US Highway 377/67) and Austin Street (State Route 16).

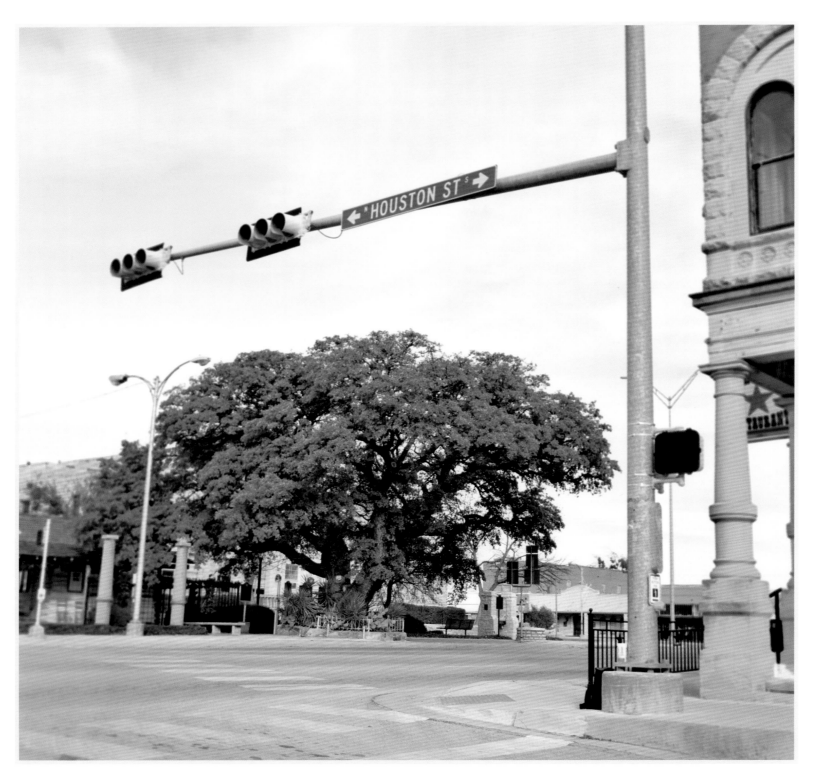

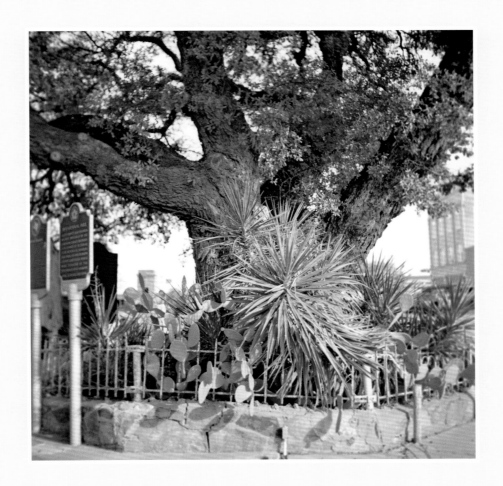

The Fleming Oak looms high over the Comanche town square across from the beautiful art moderne style courthouse and next to a log cabin that serves as a visitor center. While the Fleming Oak sits adjacent to one of many Texas streets named after Sam Houston, the true hero of this Texas town remains "Old Mart" Fleming, whose belligerence ensured that the tree would remain a fixture of the colorful town for a long while.

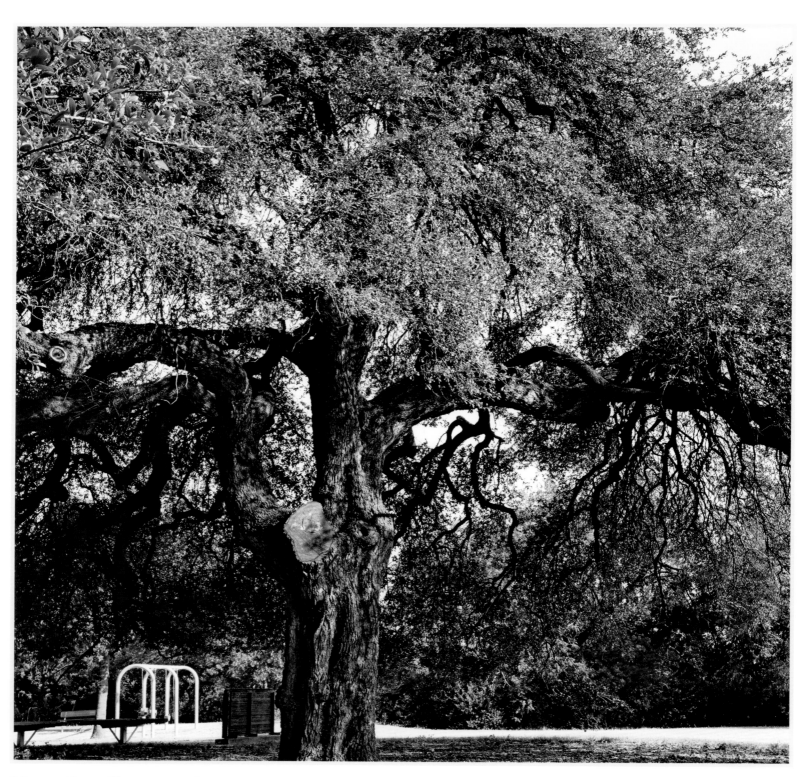

THE TRADERS OAK

❧ The tree that reminds us that the entrepreneurial spirit has always been part of the Texas landscape.

After the US Army established a military post called Fort Worth, two enterprising traders built a trading post exactly a mile away. Henry Clay Daggett and Archibald Franklin Leonard knew that regulations prohibited trading posts within a mile of any fort, so they would have measured the distance carefully. Their building stood beneath a large oak tree and next to a stream frequented by Native Americans. The trading post was successful and was the polling place for the first Tarrant County election, in 1850. The post finally closed in 1853, as the traders relocated operations to the abandoned fort.

From Interstate 35W on the east side of downtown Fort Worth, take exit 53 and head west on East Northside Drive. The road curves sharply to the left. Go past Cold Spring Road and take the exit ramp for Samuels Avenue. Turn right (south) on Samuels and proceed past Tenth Street to Traders Oak Park on the left. The tree is at the crest of the hill.

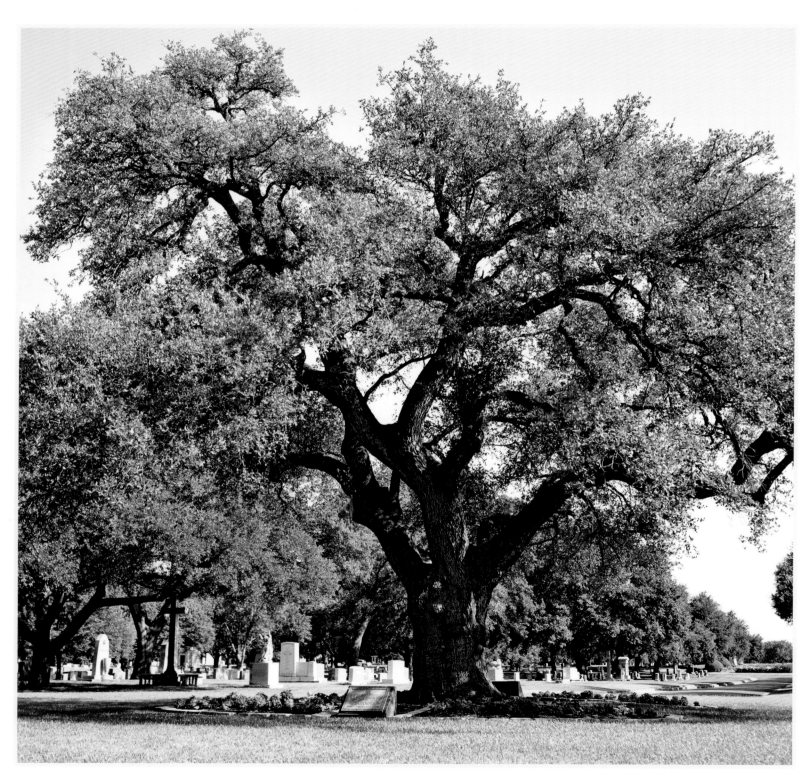

THE TURNER OAK

FORT WORTH

❧ When the city of Fort Worth needed a miracle, there really was a pot of gold beneath this tree.

From the Tarrant County Courthouse (100 West Weatherford Street at Houston Street), go around the courthouse by proceeding east on Weatherford, north on Commerce, and left on Belknap Street so that you are heading west. Proceed west on Belknap for not quite half a mile and turn right on North Henderson Street. Go about three-tenths of a mile, then take a left on White Settlement Drive and proceed just over a mile to Greenwood Cemetery on the right. The Turner Oak is located in the middle of a round median in the main drive, about two hundred yards from the gate. There is a bronze marker near the tree.

Charles Turner was one of the founders of Fort Worth. When secession talk filled the air in 1861, he expressed his dismay at the idea of leaving the Union. When the state went ahead and seceded, he grudgingly went along and even paid to raise a company of Confederate soldiers. Still, he had enough vision to bury a cache of gold under a large oak tree for the community to use during the hard Reconstruction years. Ironically, the tree that played a key role in Fort Worth's survival sits in a historic graveyard.

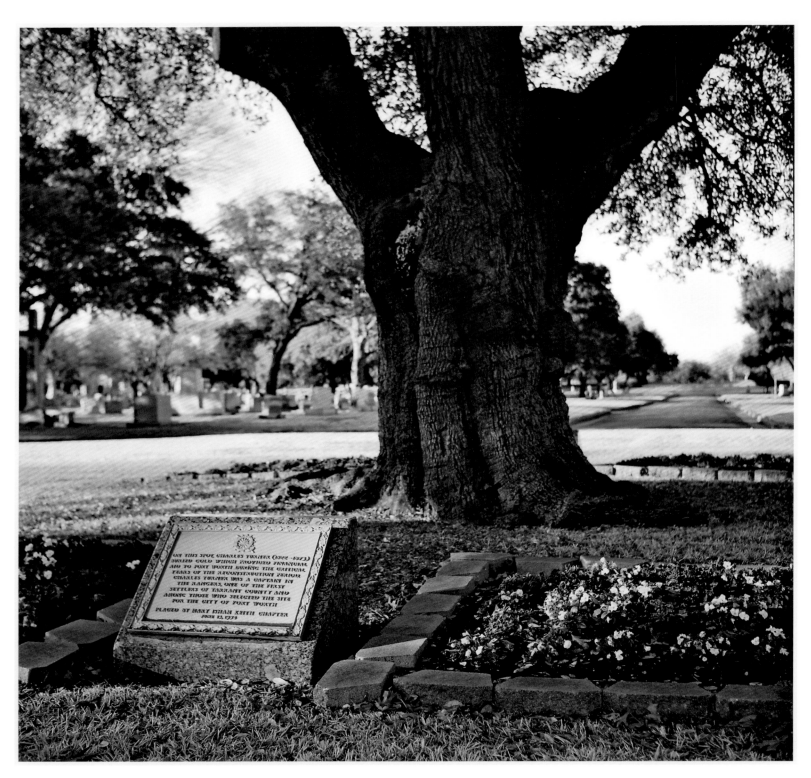

According to the commemorative plaque at the tree, "On this spot, Charles Turner (1822–1873) buried gold to help Fort Worth survive the critical reconstruction years. Charles Turner was a captain in the Rangers, one of the first settlers of Tarrant County and among those who selected the site for the city of Fort Worth."

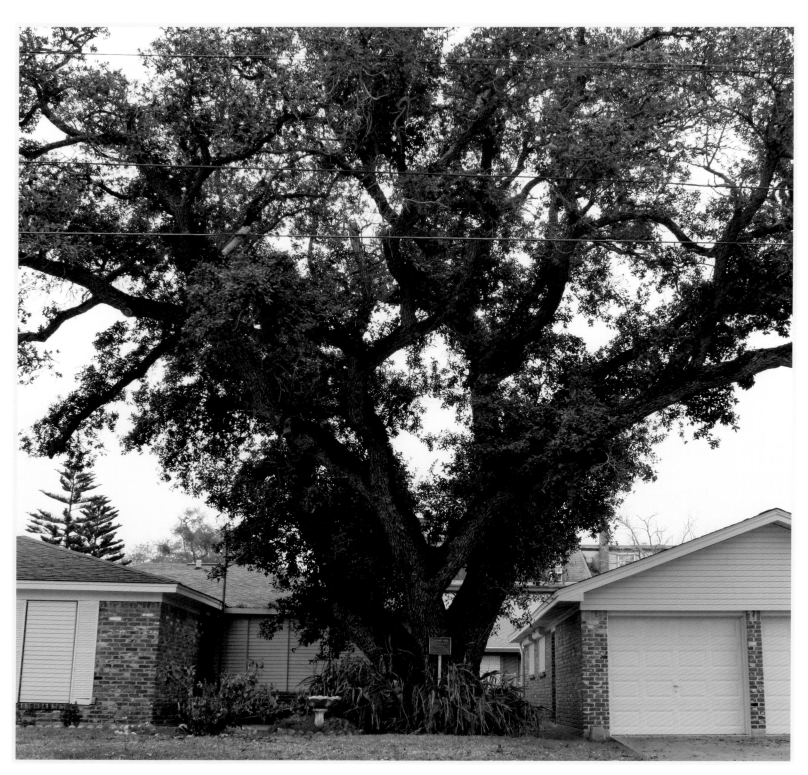

THE BORDEN OAK

GALVESTON

❧ A tree that symbolized the spirit of a city that refused to surrender.

Following the Great Storm of 1900, Galveston began the massive project of constructing a seawall and, incredibly, raising the elevation of the city by as much as seventeen feet. While the designers of the huge project intended to ensure that the city would survive future hurricanes, the massive undertaking spelled doom for the trees, whose trunks were buried beneath salty earth dumped by the truckload. One man, Thomas Henry Borden (the brother of the man who invented the process of condensing milk) refused to let the beloved oak tree he planted die. After building a dike to redirect the salty fill dirt, he continually washed the roots with fresh water until natural rain and time had leached the excess salt from the fill and healthy dirt could surround the trunk. Amazingly, a full five foot length of the trunk is below ground level, but, like the city of Galveston, the tree that refused to surrender lives on.

From the Interstate 45 Causeway (which becomes Broadway/Avenue J) onto Galveston Island, turn right on Thirty-fifth Street and go south for one block to Avenue K. Turn right and proceed to 3503 Avenue K, where the tree is located.

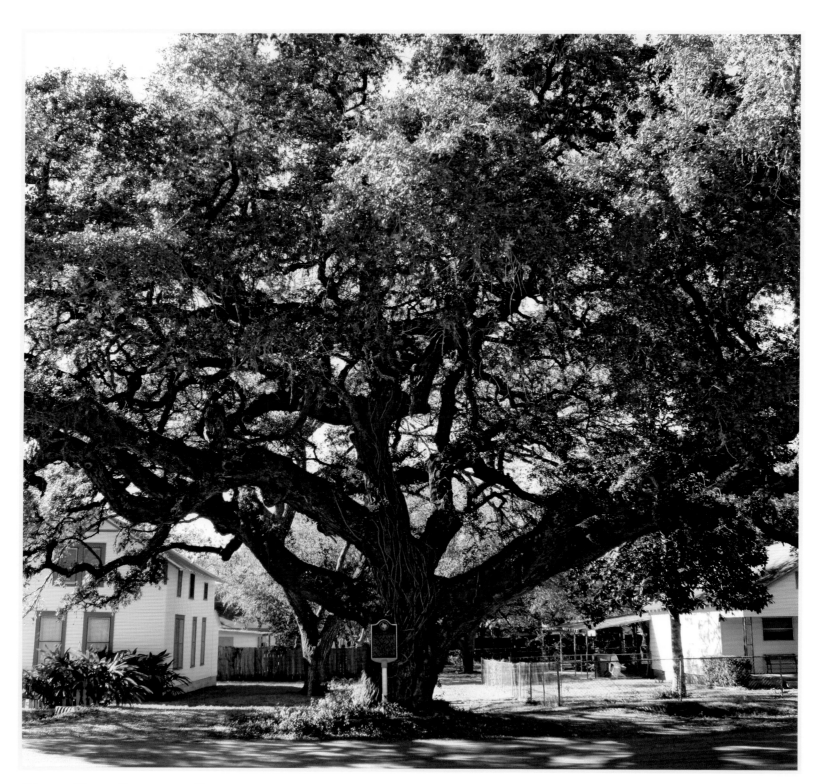

THE BAPTIST OAK

GOLIAD

❧ Not all churches have spires and stained glass windows.

In May 1849, twelve Baptist settlers organized the first Baptist church in southeastern Texas. The pastor had recently arrived from Georgia, bringing his small congregation with him. Joining him for the inaugural services beneath an expansive oak tree were his wife, the couple's two children, and eight other people, including two slaves, a husband and wife.

Goliad lies southwest of Victoria at the junction of US Highways 59 (Pearl Street) and 183 (Jefferson Street). From that intersection, take Pearl Street west four blocks and turn left on South Chilton Avenue. The Baptist Oak stands at 248 South Chilton Avenue, across the street from the Goliad city hall and fire station.

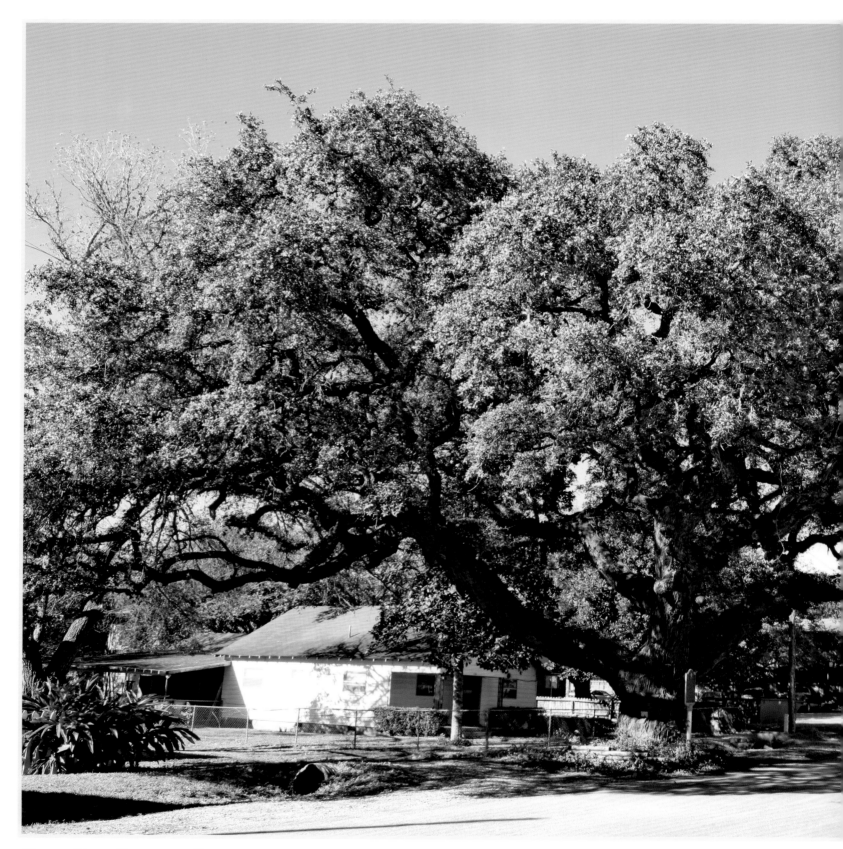

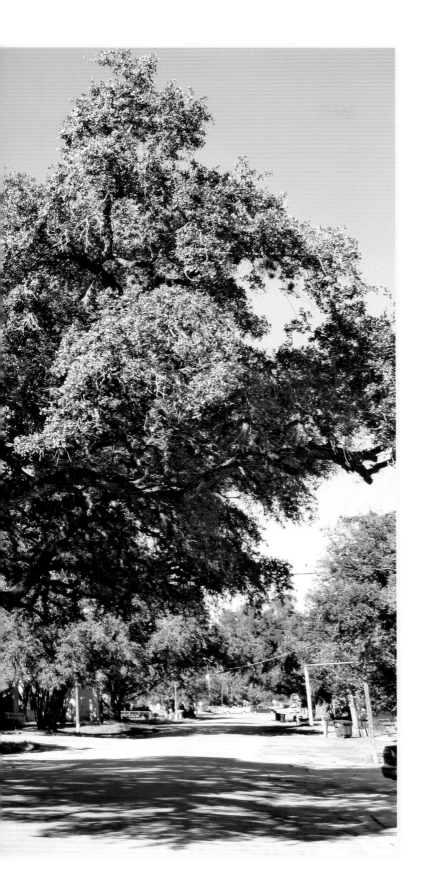

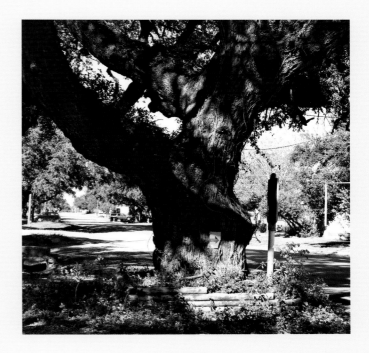

The tree stands on the quiet street only a block from the town square, among beautiful, well-maintained homes. The plaque on the square tells us that the First Baptist Church of Goliad continues to serve the area.

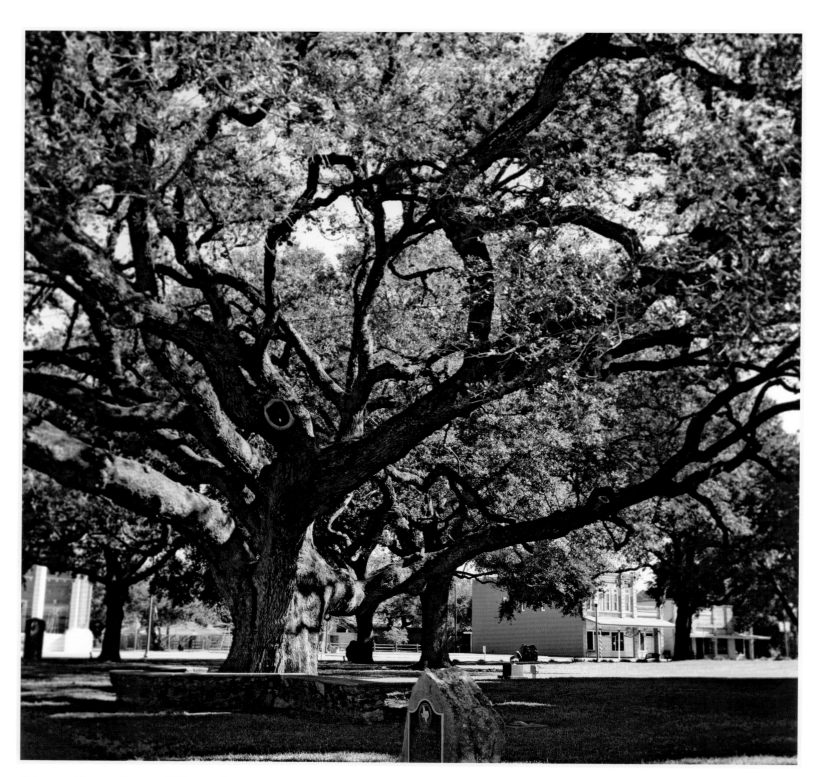

THE CART WAR OAK

GOLIAD

A curious little war settled under an enormous landmark.

In the 1850s, Mexican teamsters driving horsedrawn carts full of supplies were a common sight on roads between the Gulf coast and inland towns like Goliad. Anglo gangs began intercepting, robbing, and murdering the enterprising "cart men." The situation became so bad that state funds were allocated to deal with the robbers, but the people of Goliad had had enough and began taking care of the thieves in a much swifter fashion. In 1857, before state militia could intervene, most of the troublemakers were dangling from the great tree outside the courthouse in Goliad.

The Cart War Oak is located along North Courthouse Square Street, which lies between Commercial and Market streets, southwest of where US Highway 59 (Pearl Street) crosses US Highway 183 (Jefferson Street) in downtown Goliad. From that intersection, take Pearl Street west to Market Street and turn left (south) on Market Street, cross Franklin Street, and proceed to North Courthouse Square.

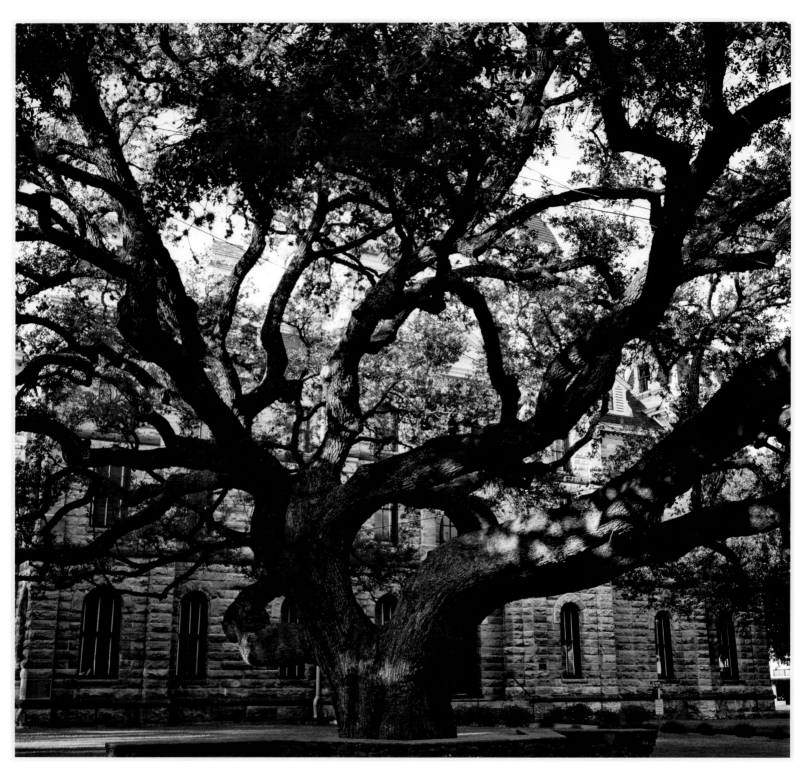

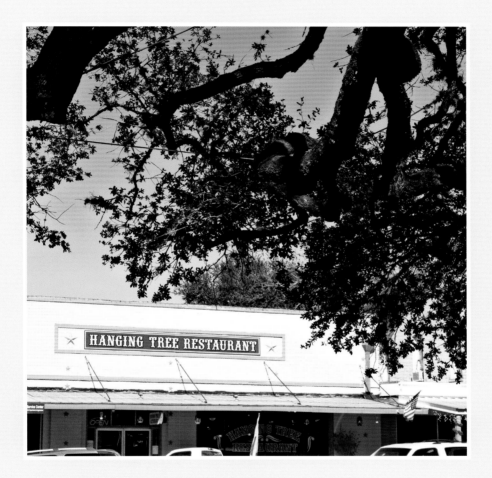

Despite its advanced age, the great tree of Goliad continues to flourish. Its expansive reach dominates the picturesque town square. An historical marker solemnly recounts the tree's role in rough frontier justice. On a slightly lighter note, the Hanging Tree Restaurant provides a more inviting welcome than the one that the highwaymen received more than 150 years ago.

THE RUNAWAY SCRAPE OAK

GONZÁLES

🍂 Where a resourceful general and his army sought refuge in 1836 on their journey to history.

The people of Gonzales are rightly proud of their town's early role in the struggle for Texas independence. In March 1836, camping beneath the limbs of an oak tree that seemed to stretch out forever, Sam Houston gathered his tiny army. Hopelessly undermanned and outgunned, he chose to retreat eastward in an action that has gone down in history as the "Runaway Scrape." The people of Gonzales followed the volunteers east, burning their beloved town as they departed.

Gonzales lies about an hour's drive east of San Antonio. To reach a spot from which the tree may be viewed, take US Highway 183 south from Interstate 10 into town. From US 183 (Water Street), turn left (northeast) on St. Louis Street (Spur 146) and proceed two miles. At US Highway 90 Alt., proceed eastbound eight miles (crossing Peach Creek) and then turn left on County Road 361. Go about a third of a mile to a driveway that leads to a historic old house. The tree is located on the right of the driveway on private property, so the tree (also known as the Sam Houston Oak), should be viewed from the county roadway.

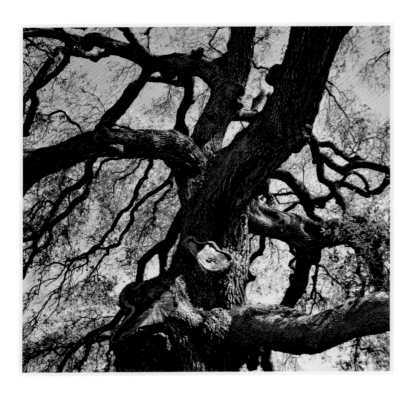

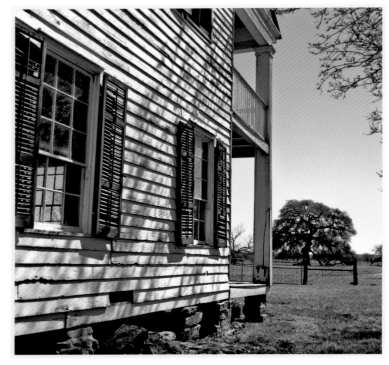

Today, the redoubt-like oak
continues to stand guard over
the stately McClure-Braches
property, which includes a house
built in the 1870s home and a
beautiful old cemetery.

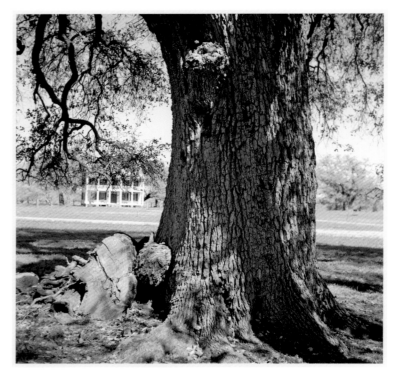

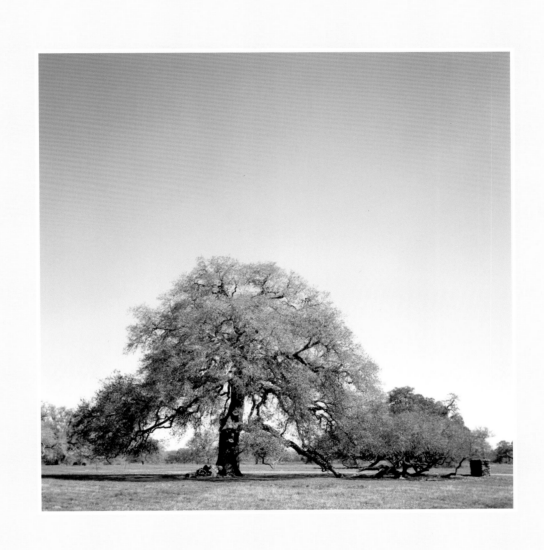

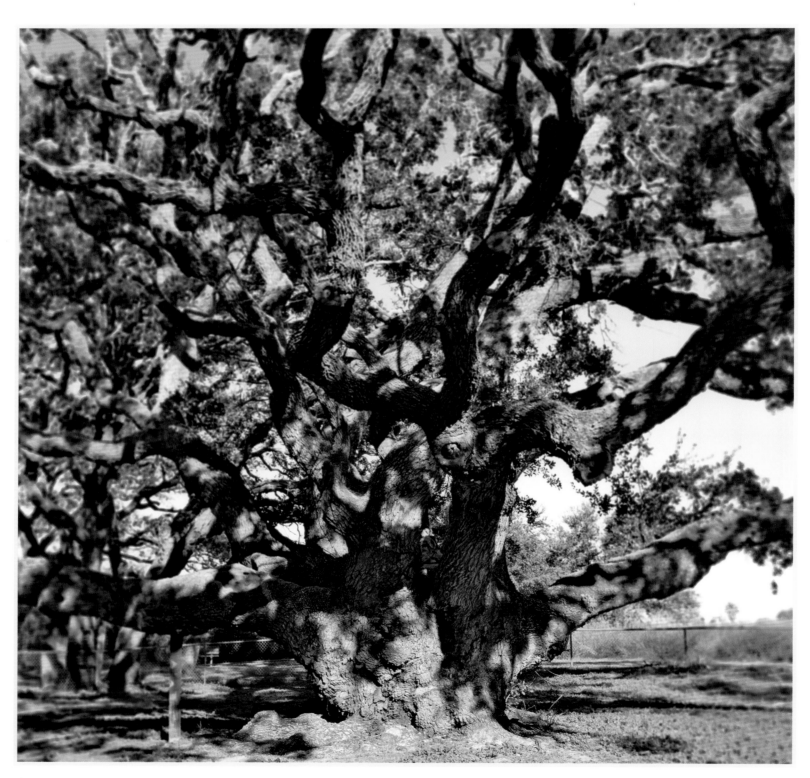

THE GOOSE ISLAND OAK

GOOSE ISLAND STATE PARK

❧ In a place where bigger is better, this tree stands alone.

While the facts about and measurements of this oak tree are astounding, one item stands above all others: the great Goose Island tree is believed to be at least one thousand years old. Possibly the most famous tree in the state, the tree has outlasted the Karankawas, who reputedly used it as a council place, and early Spanish and French explorers, who are believed to have passed by it. The town of Lamar arose nearby in the 1830s, only to dwindle. Peoples and their built legacy come and go, but the mighty oak tree continues on its seemingly endless life.

Goose Island State Park is located in Aransas County adjacent to the Aransas National Wildlife Refuge along St. Charles Bay. From downtown Rockport, take Business Route 35 north for about eight and a half miles, passing through Fulton and crossing the LBJ/Copano Bay Causeway into Lamar. Take a right on Park Road 13 and enter Goose Island State Park. Signs direct visitors to the tree.

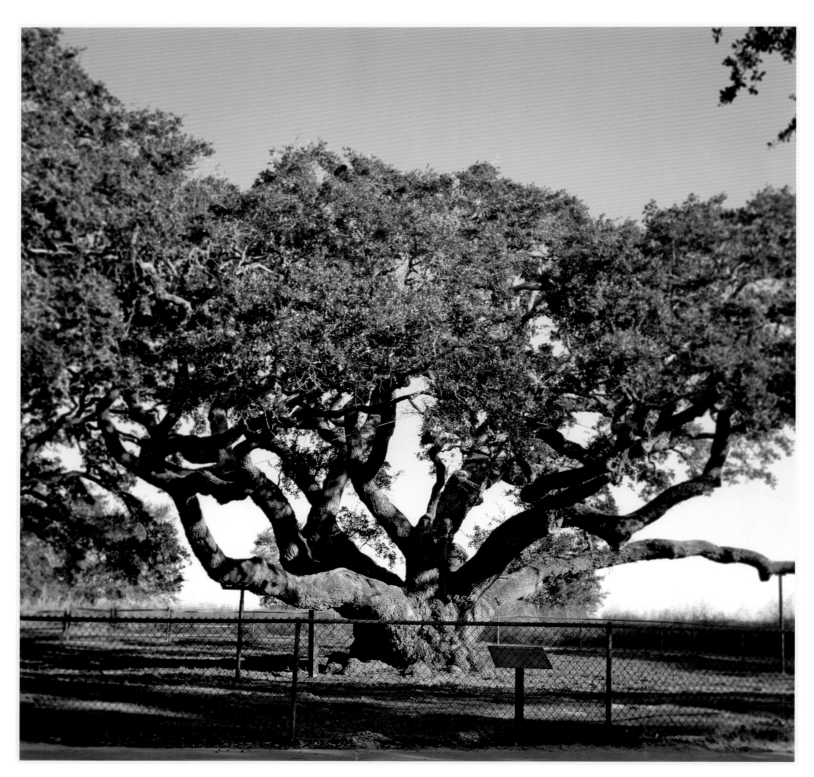

The Goose Island Oak is well cared for and is looking as healthy as ever. The park is a beloved destination for bird watchers, so if you visit the great tree you can find out what birds are currently on the island from the visitors standing alongside you. A chainlink fence keeps viewers at bay, but when you are viewing a tree of this size, standing a little farther back does not diminish your view—it gives you a panoramic vista.

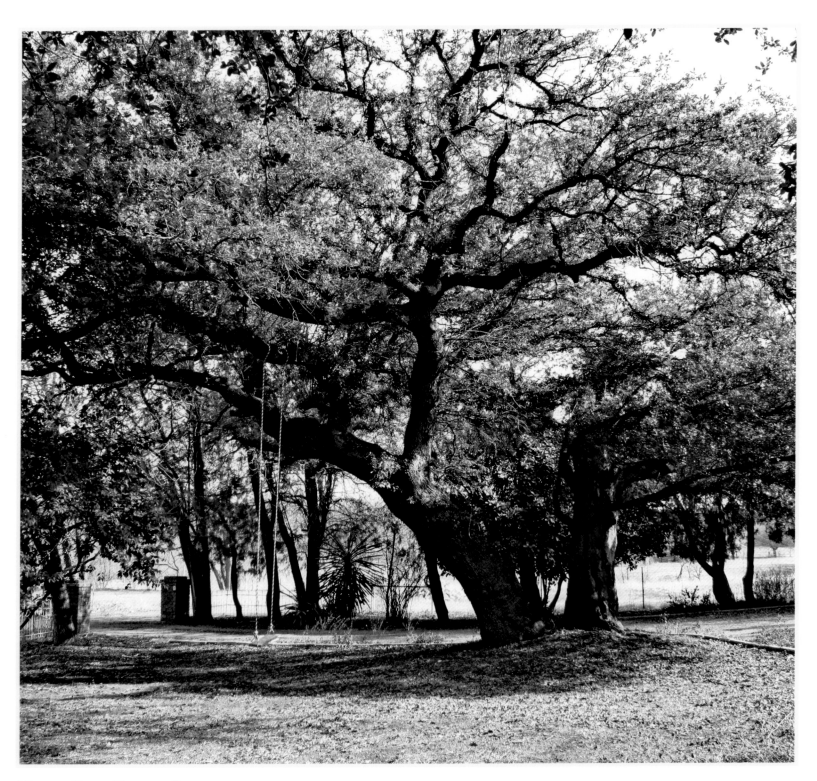

The Twin Oaks

HAMILTON

Despite living for hundreds of years, they are most famous for the life they could not save.

The Twin Oaks of Hamilton were the scene of another tragic confrontation between Native Americans and settlers. While riding to town on his mule on December 24, 1866, William Willis faced an attack by hostile Indians. Wounded, he headed for the nearby home of Judge James Monroe. Outside the judge's home, Willis fought off his attackers by taking cover behind a pair of oak trees and wounding the chief. Local men pursued the raiders, but cold temperatures forced them to abandon the chase. Willis succumbed to his wounds three weeks later, making him the last casualty in Hamilton County in the struggle with the Native Americans.

Hamilton is the seat of Hamilton County and lies northwest of Fort Hood at the junction of State Route 36 (Main Street) and US Highway 281 (Rice Street). From that intersection, take US 281/Rice Street south nine blocks and turn left onto Baker Street. Go to 222 East Baker Street, turn right onto a private drive (opposite South Railroad Street), and proceed for about a tenth of a mile to a state historical marker. The twin trees are inside a circle drive.

One of the trees soars majestically above the property, while the other has clearly seen better days. The trees share the pretty Hill Country setting with an early twentieth-century home and a flock of curious sheep. While a historic plaque recounts the story of William Willis' fight, that fateful day is also memorialized by a swing that hangs from the limbs, reminding us that the judge's young daughters were playing beneath the tree when Willis came galloping up all those years ago.

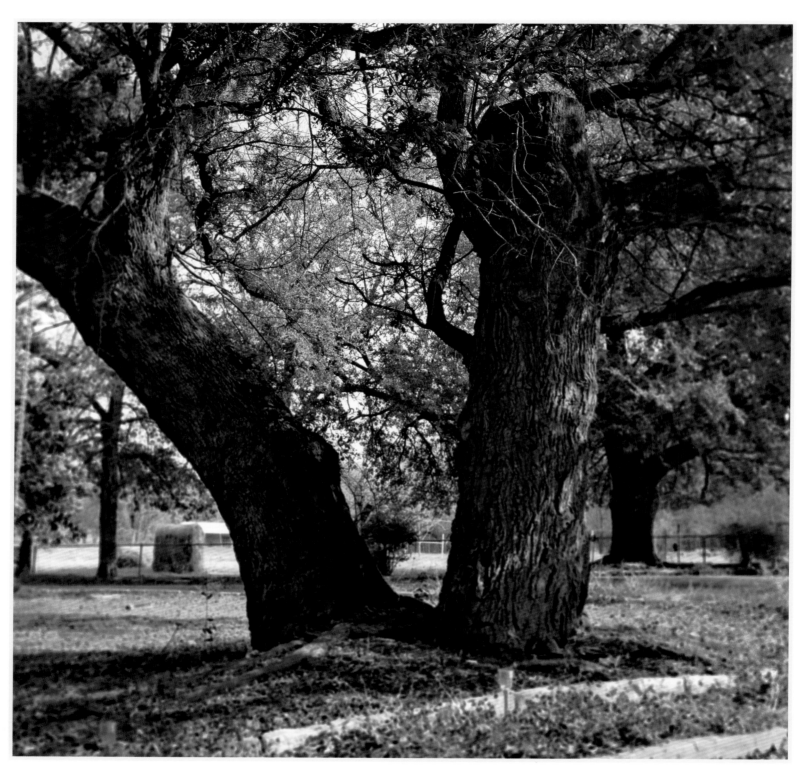

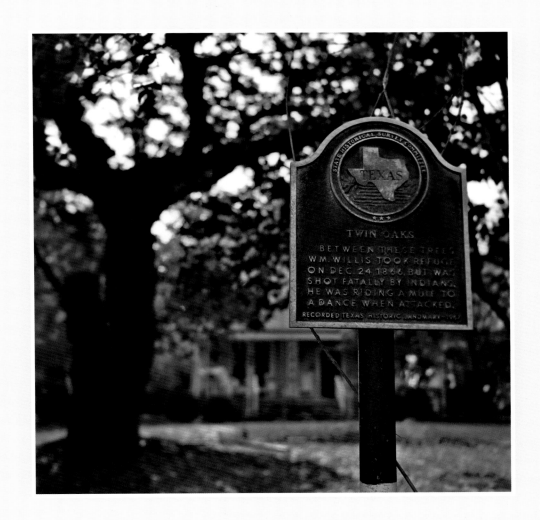

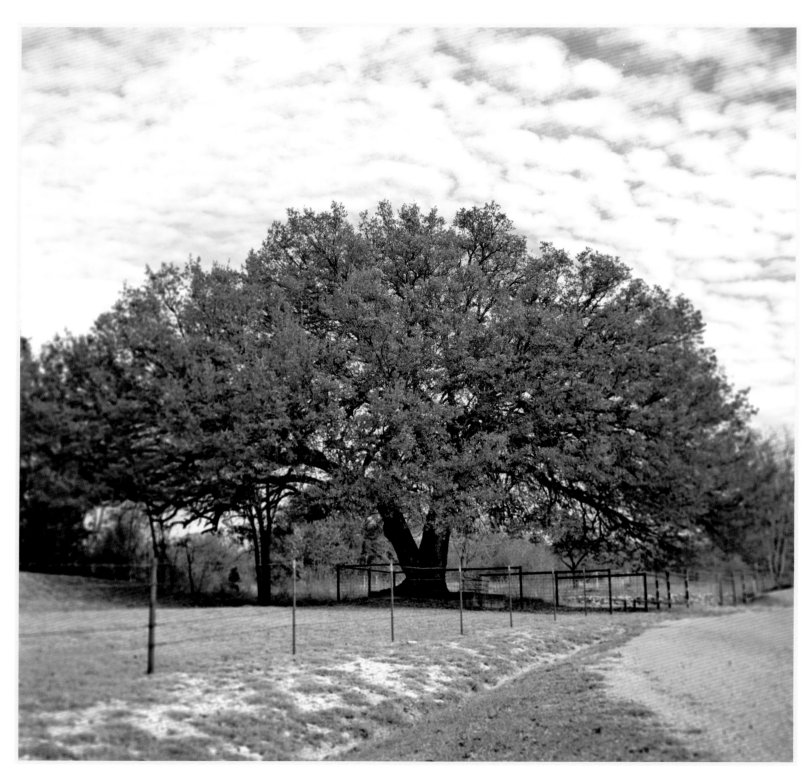

THE CHOCTAW ROBINSON OAK

HAZEL DELL

All-day sermons appropriately held beneath a tree that has survived for an eternity.

The tough town with the feminine name of Hazel Dell attracted rough characters in the nineteenth century, so a preacher named William Robinson decided that it was a place that needed a healthy dose of sermonizing. His favorite preaching spot was a large twin-trunk oak tree that grew alongside a popular saloon, store, and the post office. He would commence his sermonizing by first laying his rifle in the fork of the great tree, and then he would preach for hours on end. When a group of Choctaw Indians became impatient for the sermon to end, the long-winded preacher acquired the nickname "Choctaw Bill" and the tree became the Choctaw Robinson Oak.

Hazel Dell is in southeastern Comanche County, just to the northwest of Hamilton County. From the county seat of Comanche, take State Route 36 to the southeast approximately fifteen miles and turn north on Farm Road 1702. Proceed slightly more than two and a half miles to Hazel Dell (often identified as Hazeldell on commercial maps), and then turn left (west) on Ranch Road 591 and go about a third of a mile to the Choctaw Robinson Oak.

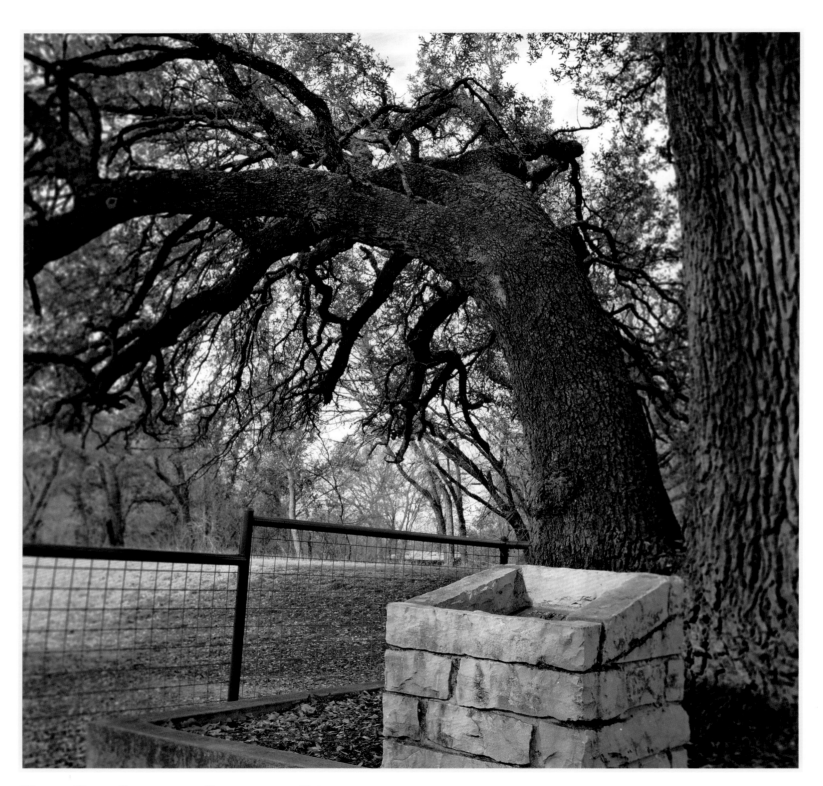

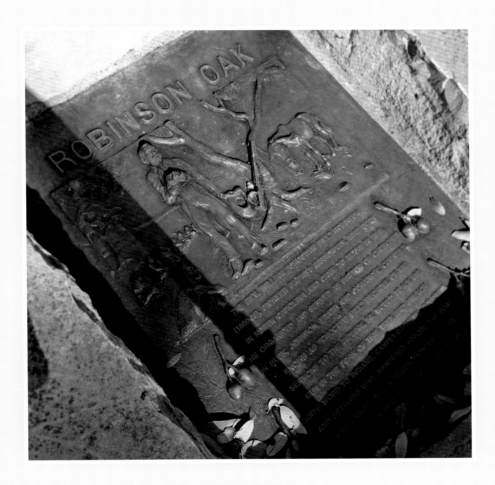

The stolid old tree looks as healthy as ever and holds claim to possibly the hardest-working plaque in the state. Don't be fooled by the seemingly lazy country atmosphere, however; the tree trunk is home to an industrious colony of bees that seemingly share the indomitable work ethic of the old preacher.

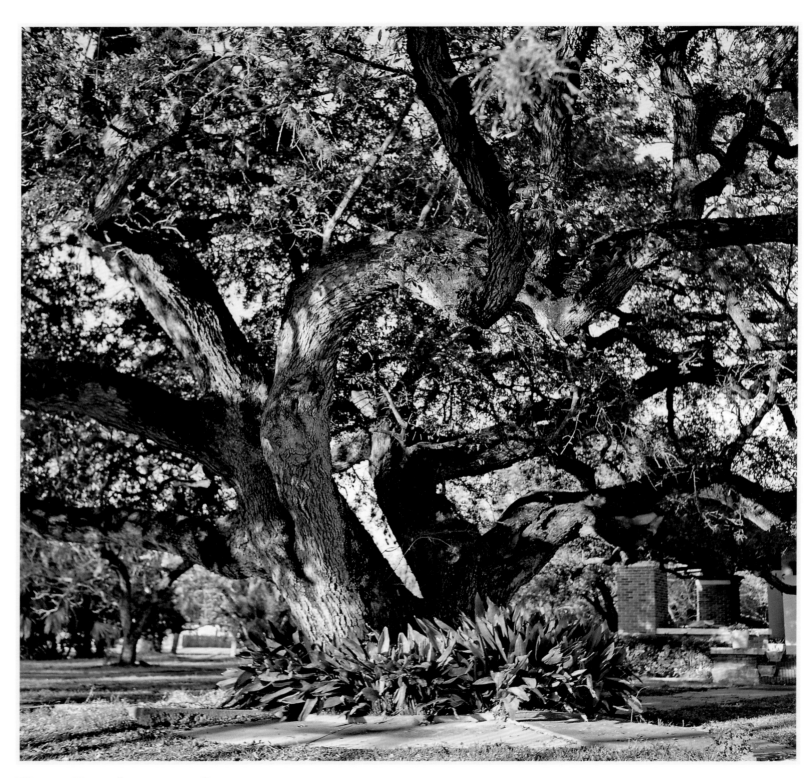

THE AUCTION OAK

KYLE

Following a land auction under this tree in 1880, the town of Kyle sprang up.

The town of Kyle began as a place for trains to pick up supplies between Austin and San Antonio. Captain Fergus Kyle, a Civil War veteran, owned a great deal of the land south of Austin, and he agreed to sell it to make the proposed train stop a proper town. One clear day in 1880, people gathered beneath a sprawling oak tree and purchased individual lots from the parcel of land Kyle and his wife had deeded for the townsite. By the end of the day, all the land had been distributed, and people could get along with the business of building houses, barns, stores, restaurants, and everything else that nineteenth-century country life required.

From Interstate 35 between Austin and San Marcos, take exit 213 for Farm Road 150 and follow FM 150 (Center Street) westward into the downtown area. Turn left on South Sledge Street and proceed slightly more than one block. The tree and a historical marker are on the right, at 204 South Sledge Street.

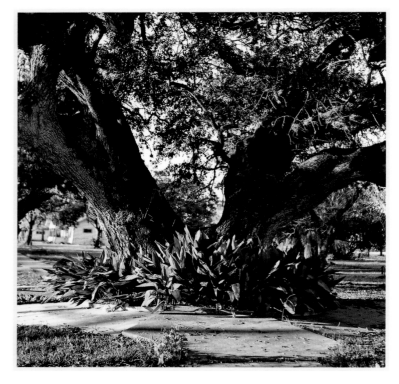

Like the quiet town, the tree continues to flourish, and now its branches spread out magnificently among stately homes. As a reminder that the town was conceived during a more genteel time, the sidewalk curves respectfully around the widespreading tree. A historical marker details the history relating to the tree. Some people believe one of the houses close to the tree is haunted. Perhaps it is the ghost of Captain Kyle himself, making sure the town he helped create remains prosperous today.

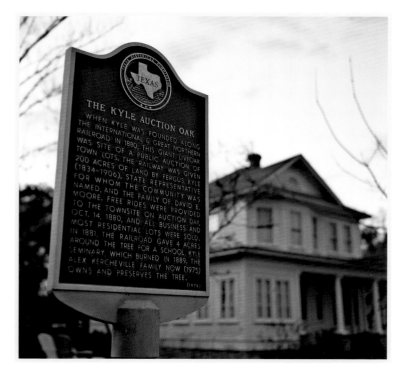

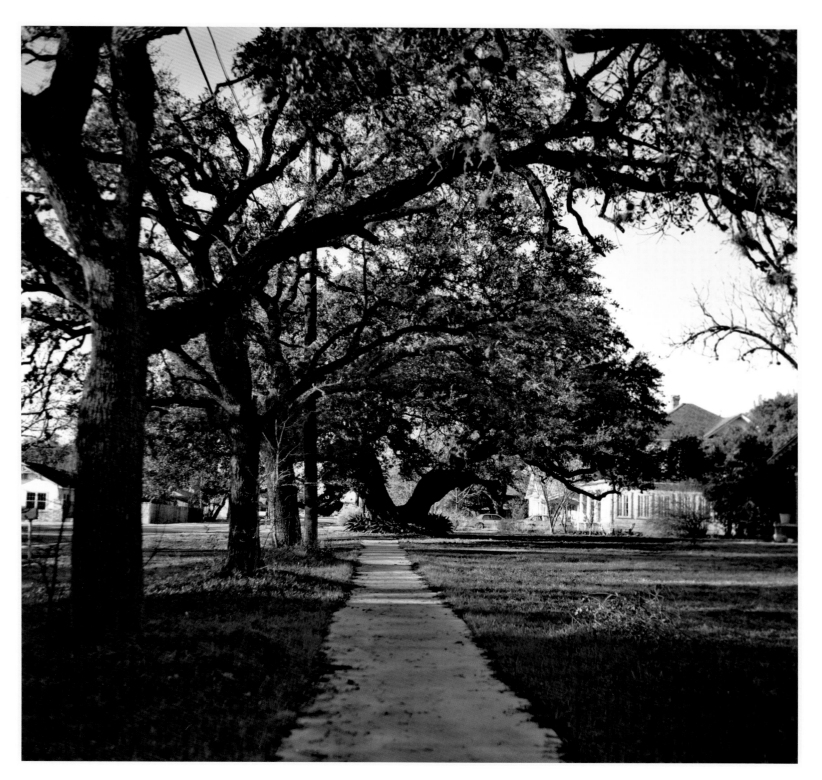

THE HANGING OAK

KYLE

🌿 An unknown cowboy was discovered hanging from this tree that, appropriately, sits in a historic graveyard.

From Interstate 35 between Austin and San Marcos, take exit 213 for Farm Road 150 and follow FM 150 (Center Street) westward into the downtown area. Proceed on Center Street (past the point where FM 150 turns to the right, which is past Wallace Middle School) until you come to a multi-prong fork in the road. Take a left on South Old Stage Coach Road and go two miles to the Kyle City Cemetery (by-passing a smaller cemetery). A historical marker is at the top of the main cemetery drive. A new marker is at the base of the tree, which is about two hundred feet up the right-hand cemetery drive, on the right.

The story of the Kyle Hanging Oak is brief. In the late 1840s, cowhands from the Kyle Ranch discovered a hapless soul hanging from the branches of this tree. They carefully cut the rope and buried the body in an unmarked grave in the year-round shade of the live oak branches. Whether he was the victim of frontier justice or on the wrong side of a petty feud has never been determined. Others were laid to rest in the vicinity of the unknown cowboy's grave, creating the evocative little graveyard that remains to this day.

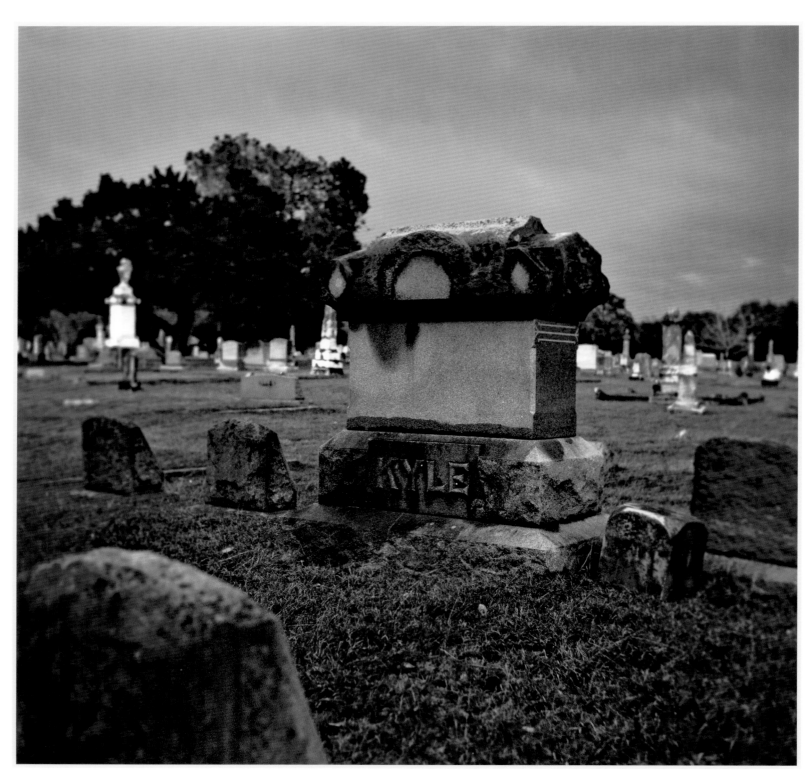

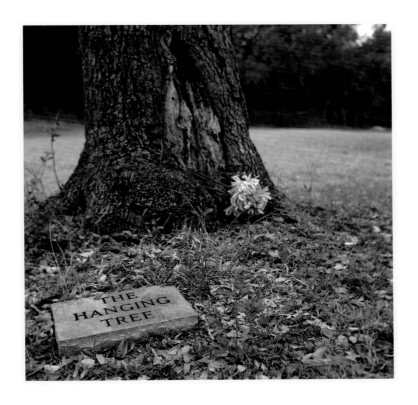

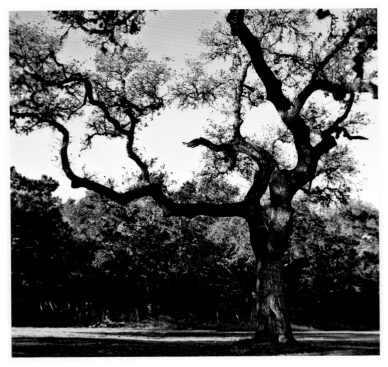

The markers in the picturesque graveyard contain the names of those who helped Kyle gain its place in the world, including that of Captain Fergus Kyle, for whom the town was named. A simple marker for the hanged man lies beneath the tree, an enigmatic reminder of a time when retribution was swift and conclusive.

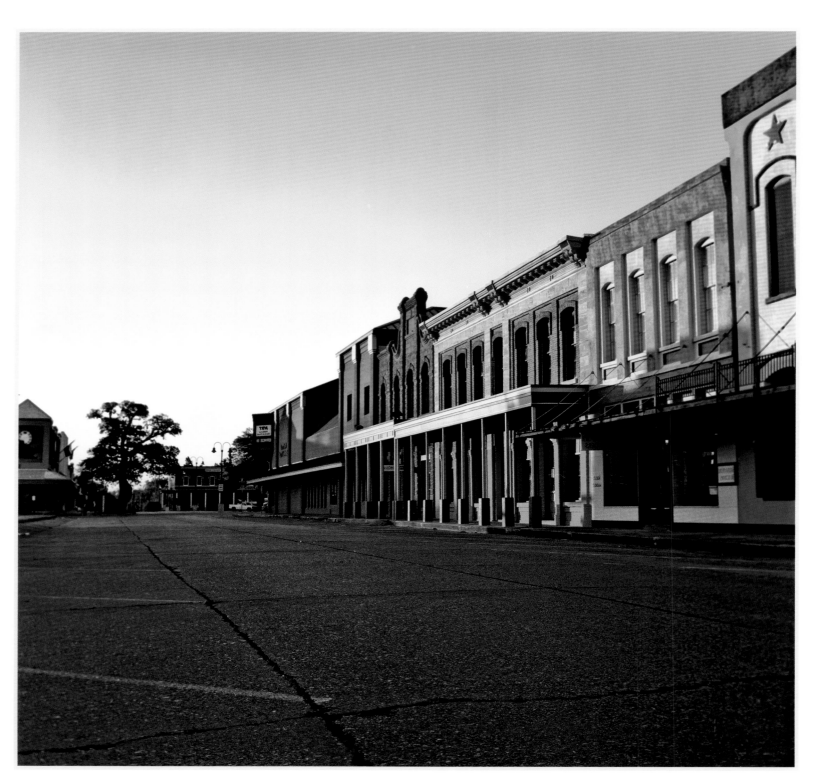

THE MUSTER OAK

LA GRANGE

🌿 Gather around the tree where earlier Texans gathered to prepare for war.

Situated in the town square, the Muster Oak has served a specific military purpose: beginning with the Texas War of Independence, the men of La Grange gathered here to enlist. The plaque on the tree states, "Here on the courthouse square the sacred remains of what was once a mighty oak marks the spot from which Fayette County has on every occasion sent its sons to battle. Wives, mothers and sweethearts have bade farewell here and sent their men to war, each time to win acclaim as patriots." The view of the sun shining on the buildings near the old oak tree was probably the last view of the town for many young men of La Grange.

La Grange lies north of Interstate 10 at the junction of US Highway 77 (Jefferson Street) and State Route 71. From the intersection of US 77/Jefferson Street and Business Route 71 (Travis Street), go one block north on Jefferson and one block west on Colorado. The Muster Oak is located directly across from the Fayette County Courthouse, at the corner of West Colorado and North Washington streets.

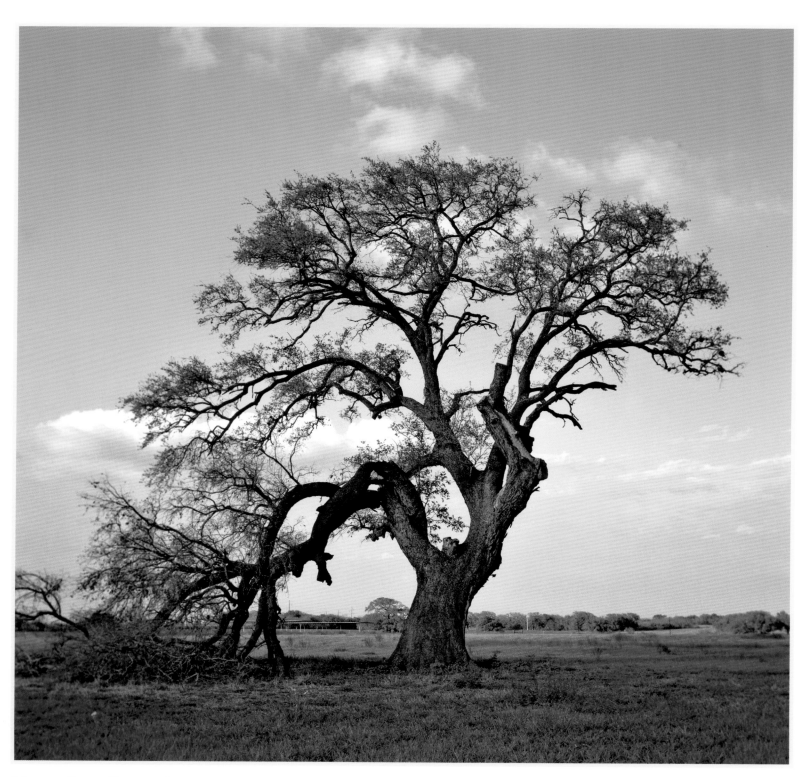

The Deaf Smith Oak

LA VERNIA

🍂 From these branches, Deaf Smith spotted the Mexican army in 1835, and today they show us where a new nation began.

I n the fall of 1835, any notion of reconciliation between the Mexican authorities and the Texas rebels had been put to rest by the battle over a cannon at Gonzales. The Mexican army at San Antonio, under the command of Colonel Ugartechea, headed out to punish the rebels. The Texans were also gathering, and Stephen F. Austin soon had a small army of five hundred men under his command. This force sent its best scout, Erastus "Deaf" Smith, ahead to discover the whereabouts of the Mexican troops. In a pasture east of San Antonio was a tall oak, and Deaf Smith is said to have climbed high in the branches and spotted the Mexican army camped along nearby Cibolo Creek. However, the Mexican troops must have had spies, too. Apparently, upon learning of the size of the Texas force, the Mexican army returned to San Antonio, delaying the fight until another day.

The tree still stands sentry in the open field and has a commanding view of the creek, but it now faces a fight every bit as meaningful as the one before: an invasion of wood ants.

The town of La Vernia is about twenty-five miles east of San Antonio on US Highway 87. From US 87, turn north onto Farm Road 775 (Seguin Street) and proceed not quite two miles. Turn left on Circle N Lane. The tree is located on private property, less than half a mile down this lane on the right, just west of some silos.

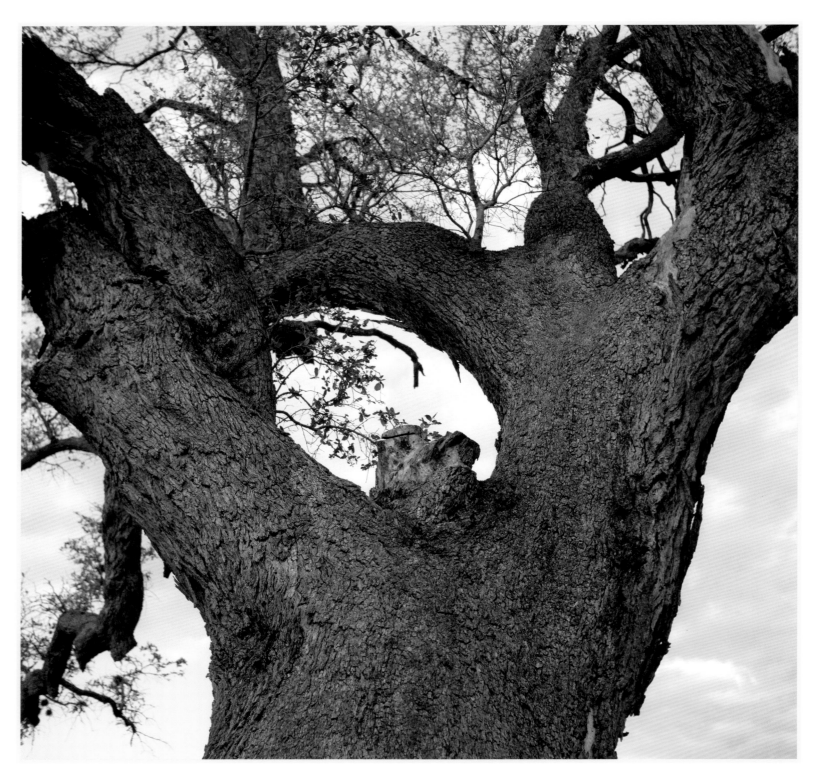

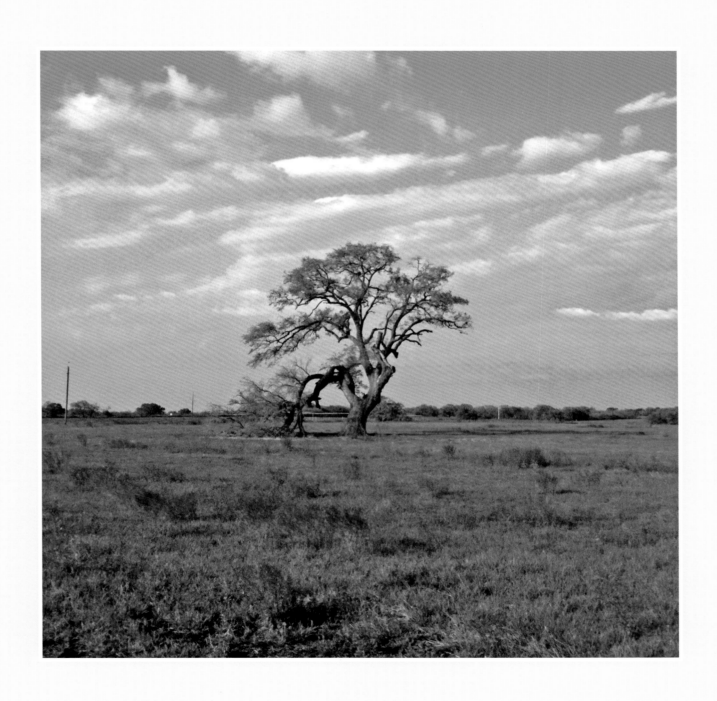

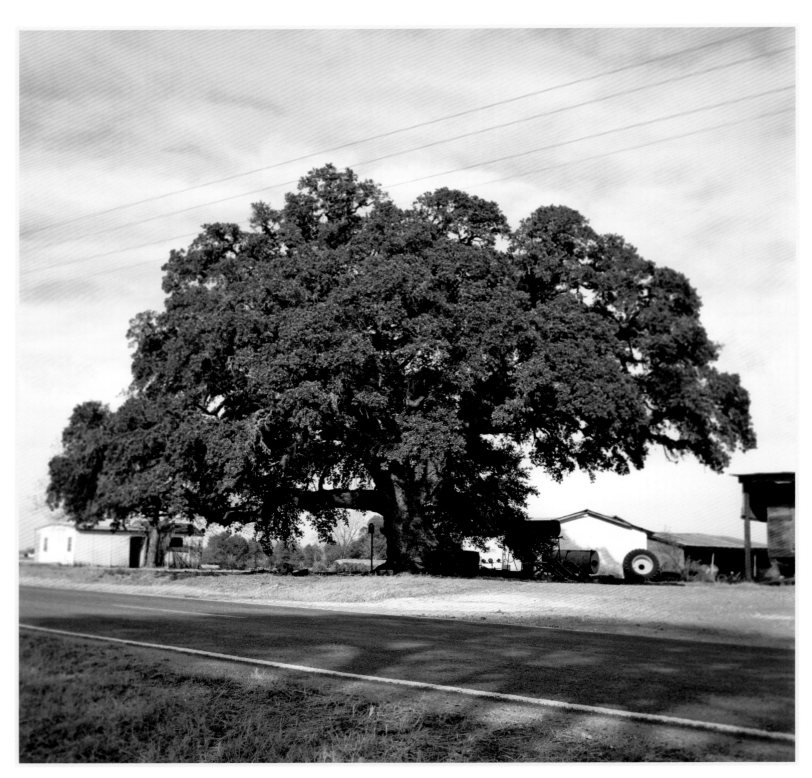

THE OLD EVERGREEN TREE

LINCOLN

Old enough to have sheltered the first European explorer in Central Texas, young enough to outlive the town that bore its name.

The simple plaque at this tree reads, "Said to have sheltered in 1714, explorer St. Denis—probably first white man ever here. Site of pioneer court trials in 1870's." Captain Louis Juchereau de St. Denis, a fearless French-Canadian explorer, left Louisiana to explore the vast, uncharted lands then claimed by the King of Spain and to develop trade with the Spanish colony along the Rio Grande. When he reached the rolling plains just east of the Hill Country, he paused and rested beneath a huge oak tree. This tree was at that time probably already several hundred years old. St. Denis' subsequent adventures included being imprisoned in Mexico, marrying an important noblewoman, and founding several Spanish missions. Around 1856, a small town named Evergreen grew up around the tree. Bypassed by the railroad in the 1870s, the little town withered and died. Nothing remains of the town except for the name of the tree and the picturesque cemetery across the road. Like the memory of the intrepid explorer, the seemingly indestructible tree lives on.

The Old Evergreen Tree is near the village of Lincoln, which is on State Route 21 north of Giddings. From Giddings, where US Highway 290 (Austin Street) intersects US Highway 77 (Main Street), proceed north on US 77 for a little more than six miles. Turn left on Farm Road 1624 and proceed west just over half a mile to the tree and a state historical marker on the right.

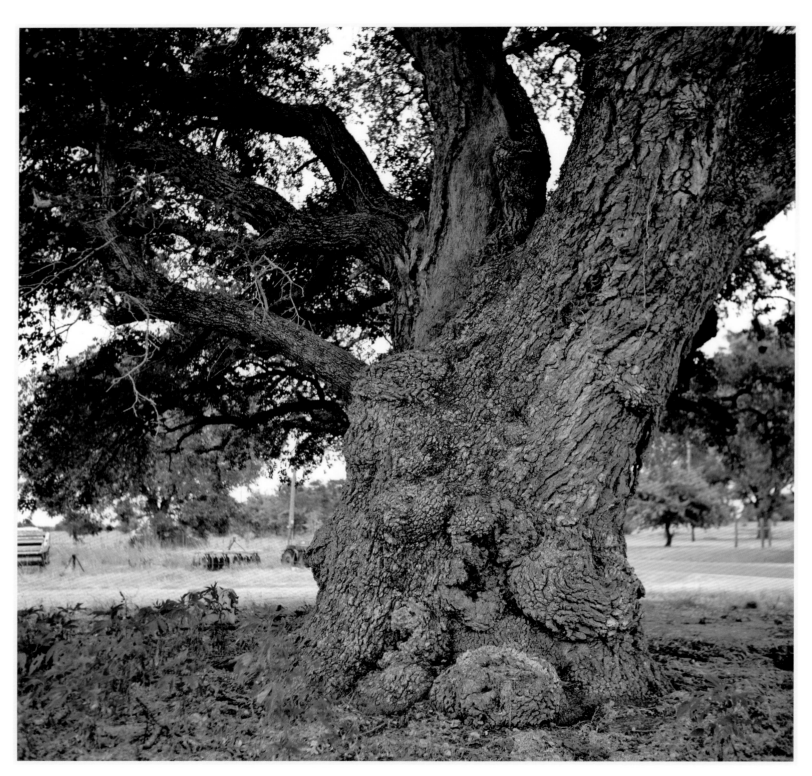

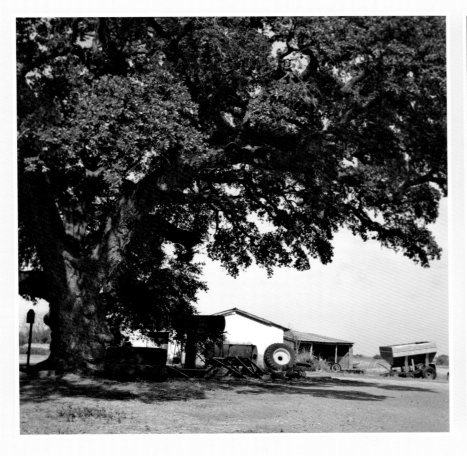

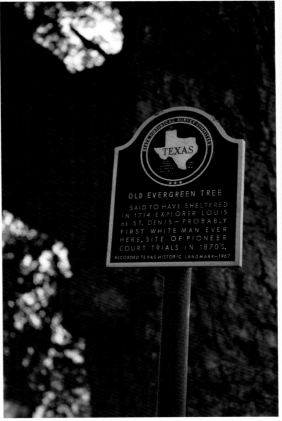

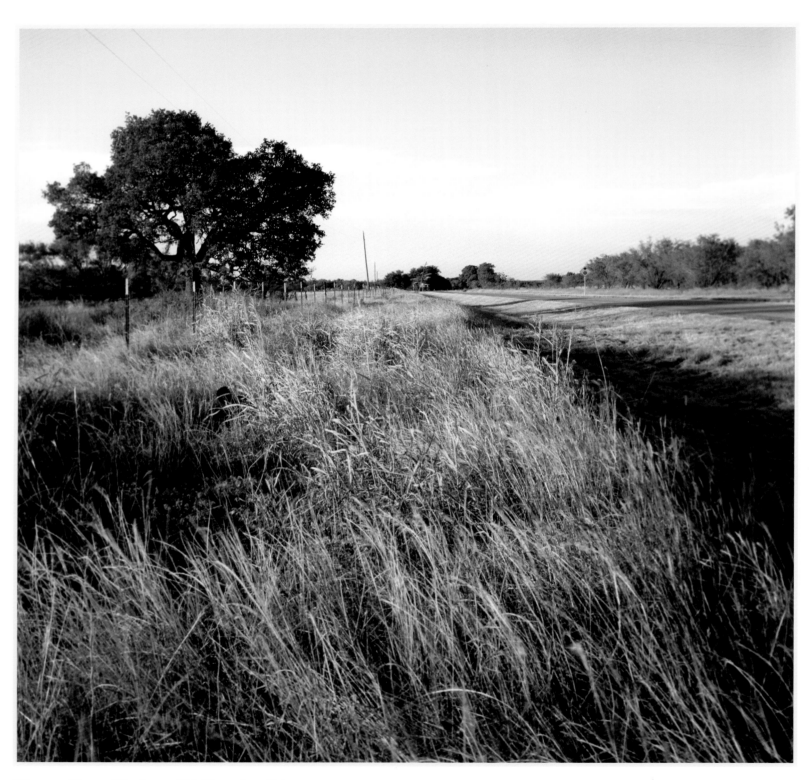

THE HEART O' TEXAS OAK

MERCURY

🌿 They didn't need a sign to mark the exact center of the state.

Along a barren stretch of road south of Brownwood stands an unassuming tree. It's not noticeably tall or beautiful, but it does hold claim to an impressive title: it stands at the geographic center of the state as determined by a survey in 1922. Situated exactly at a point where the four equal quarters of the state meet, the modest tree seems unimpressed with its oversized stature.

A plaque stands a few miles from the tree on US Highway 377, close to a state recreation area, fittingly titled the Heart of Texas State Park. The collapsed stone platform ringing the tree itself indicates that some memorial might once have stood here. The tree casts its modest shadow over a quiet country road and shares the rugged landscape with plenty of prickly pear cactus and a few inquisitive steers.

The Heart O' Texas Oak is near Mercury, in the northeast corner of McCulloch County, about halfway between Killeen and San Angelo. From Brady, the seat of McCulloch County, head north on US Highway 377 for a little more than twenty miles and then turn right on Farm Road 502. After passing through Mercury, turn south on Ranch Road 1028. Proceed two-tenths of a mile to the tree, which is about fifty feet west of the roadway.

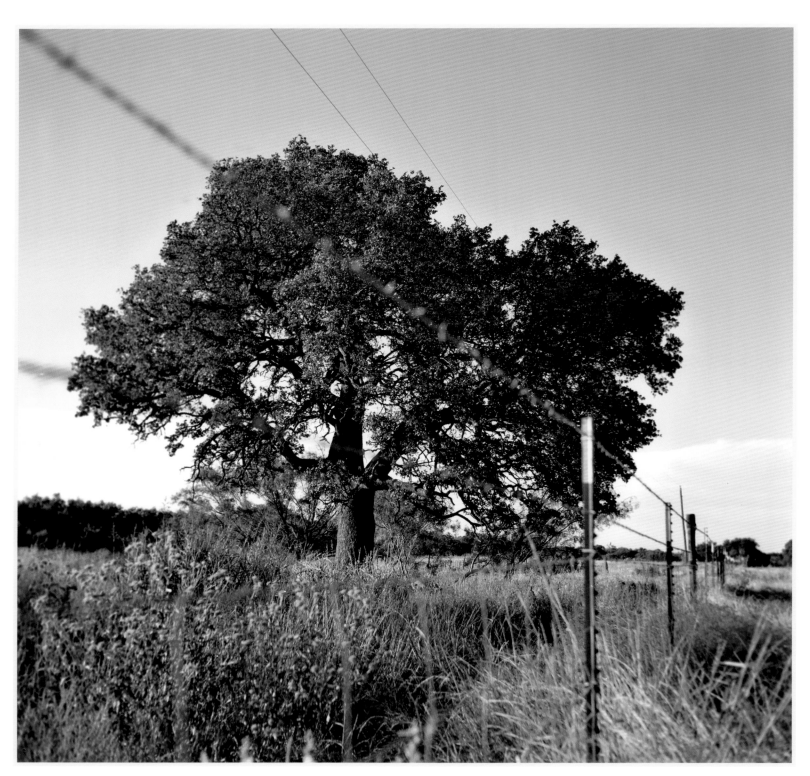

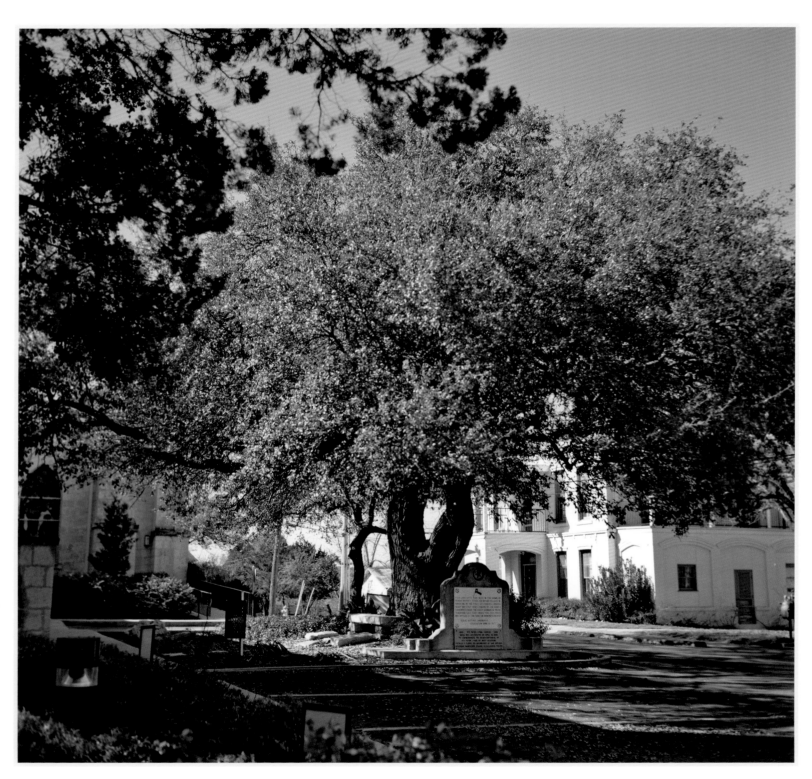

THE CHURCH OAK

NEW BRAUNFELS

❧ A missionary's story of tolerance and courage, fittingly preserved on the grounds of a church.

From Interstate 35, take New Braunfels exit 187, follow the access road, and then turn north on Seguin Avenue. Proceed all the way to the Comal County Courthouse square at San Antonio Avenue and turn southwest on West San Antonio Street. Go one block, turn right on North Castell Street, and proceed north two blocks to the parking lot of Saints Peter and Paul Catholic Church; the tree is on the east side of the church.

At the site of beautiful Saints Peter and Paul Catholic Church in New Braunfels, this tree endures, but its legend has faded. By the time the Texas Historical and Landmarks Association had placed a marker beside the tree in 1917, few historical details of its legendary witness seem to have been known. The plaque cites as its sources only folklore and tradition: "Folk-lore says here in the dawn of Texas history, stood an Indian village in which one of the early missionaries lingered many days. That here a vision of the chief's daughter freed the first German in Texas. Tradition says that under this tree, Mass was offered by the Abbe Em Domenech in 1849."

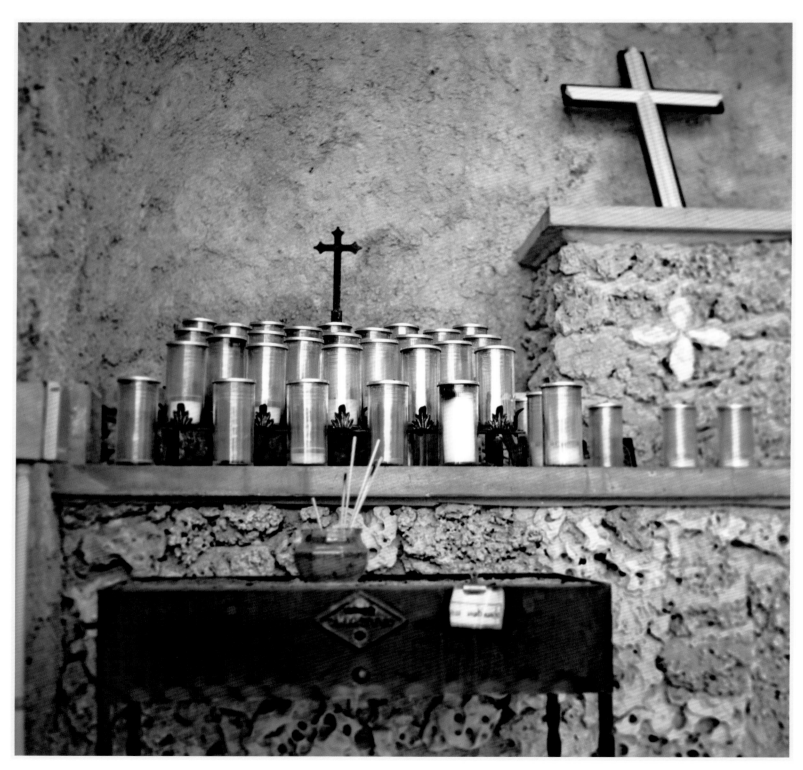

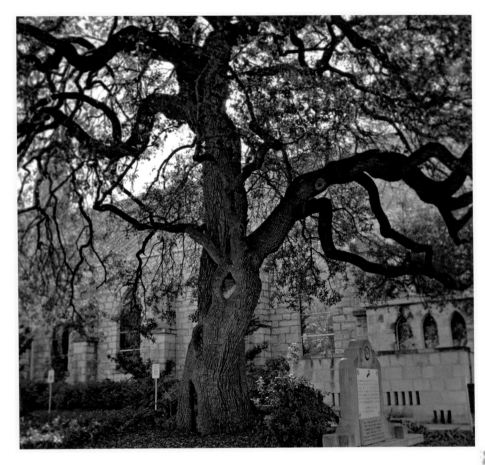

While the story's authenticity cannot be validated, a tale of mercy and tolerance is a welcome attribute for a peaceful churchyard.

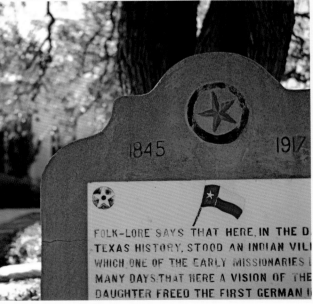

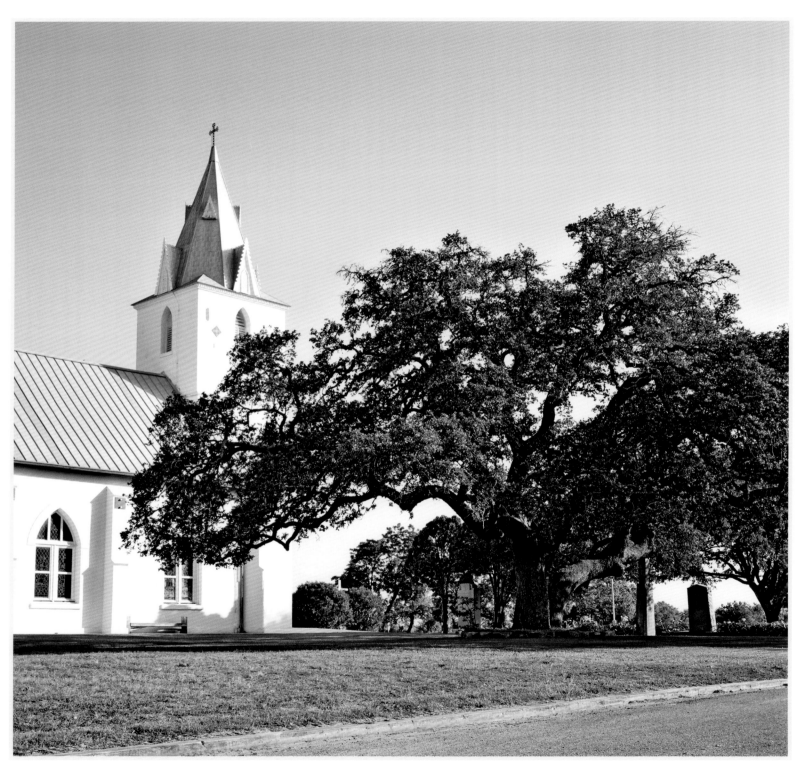

THE PANNA MARIA OAKS

PANNA MARIA

🌾 When the first Polish community in America needed a place of worship, its members looked upward.

Surprisingly, the oldest permanent Polish settlement in the United States is in south-central Texas. Unsurprisingly, the first religious service of the new community took place under some oak trees. Approximately one hundred families landed in Texas late in 1854 and then walked from the coast to an area southeast of San Antonio. There, Father Leopold Moczygemba celebrated Christmas Eve Mass under some large oak trees. In the following year, the hardy settlers in his congregation erected a traditional Polish church. Like the dutiful oaks, the lovely church still stands today.

Panna Maria is in Karnes County, southeast of San Antonio and several miles east of US Highway 181. From Karnes City, the seat of Karnes County, go north on State Route 123 approximately five miles and turn right on Farm Road 81. The Immaculate Conception Catholic Church is less than a mile down the road, on the right. The Panna Maria Oaks face the parking lot, and a Texas historical marker is nearby.

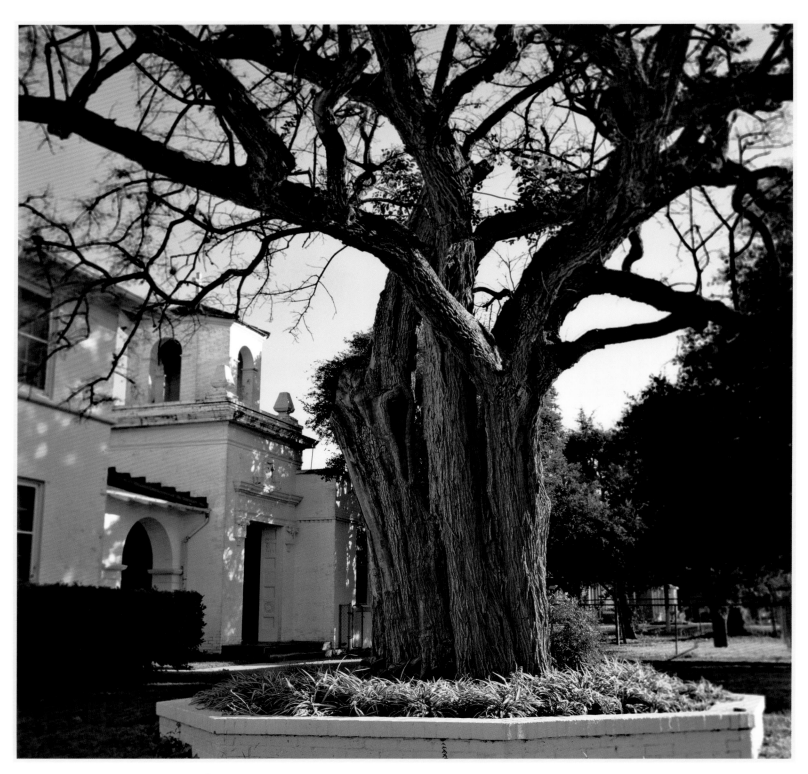

The Mission Anaqua

REFUGIO

❧ The last days of a tree that witnessed the birth of a nation.

Anyone interested in the Texas Revolution should visit Goliad and its charming neighbor to the south, Refugio. In these places, any history lover can visit a beautiful church and an anaqua tree (also known as a sandpaper tree for the texture of its leaves) that played a small role in that war that continues to transfix Texans to this day. Near this tree in the fall of 1835, Sam Houston pleaded with his men in an unsuccessful attempt to keep the tiny army together. Some of his troops impetuously broke away on an ill-fated attempt to reclaim Matamoros. The attack never transpired, and everyone in the tiny contingent was eventually captured or killed by the Mexican army under General Urrea.

Refugio is north of Corpus Christi and Rockport on US Highway 77, about a dozen miles inland from Mission Bay. The Mission Anaqua is directly behind Our Lady of Refuge Church, which is located at 1008 South Alamo Street (US Highway 77), a little more than a block south of the intersection of East Empresario Street (Farm Road 774) in the southeast part of town.

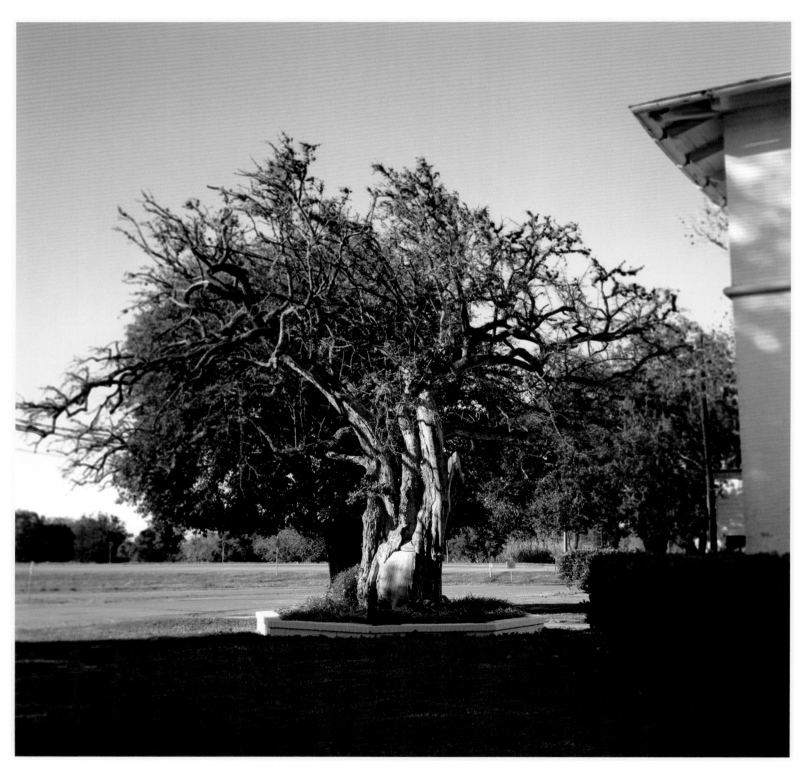

The lovely church is actually the fourth to be built on the site. No remains of the original, Nuestra Señora del Refugio, the last Spanish mission built in Texas, can be seen, but the tree, while less than healthy, carries on. The tranquil complex combines both Mexican and American architecture. The ancient tree once held the distinction of being the largest of its species, but posturing of this sort in the sacred setting seems a bit profane.

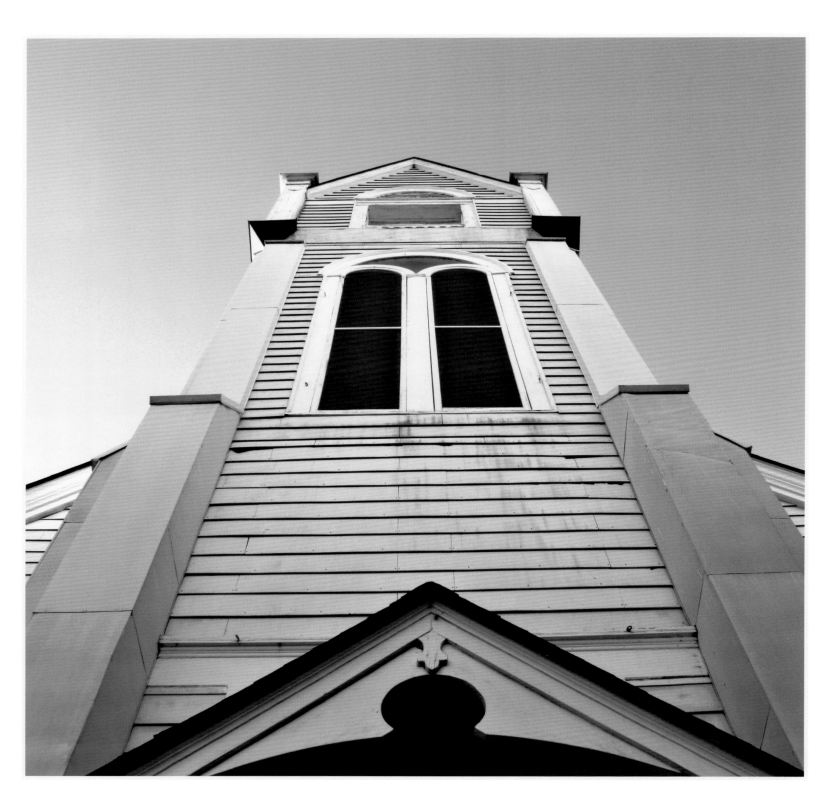

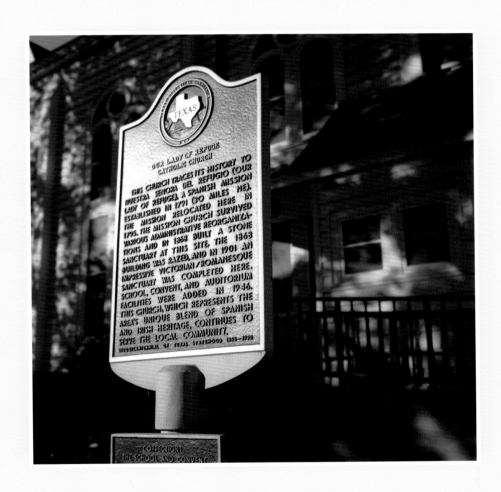

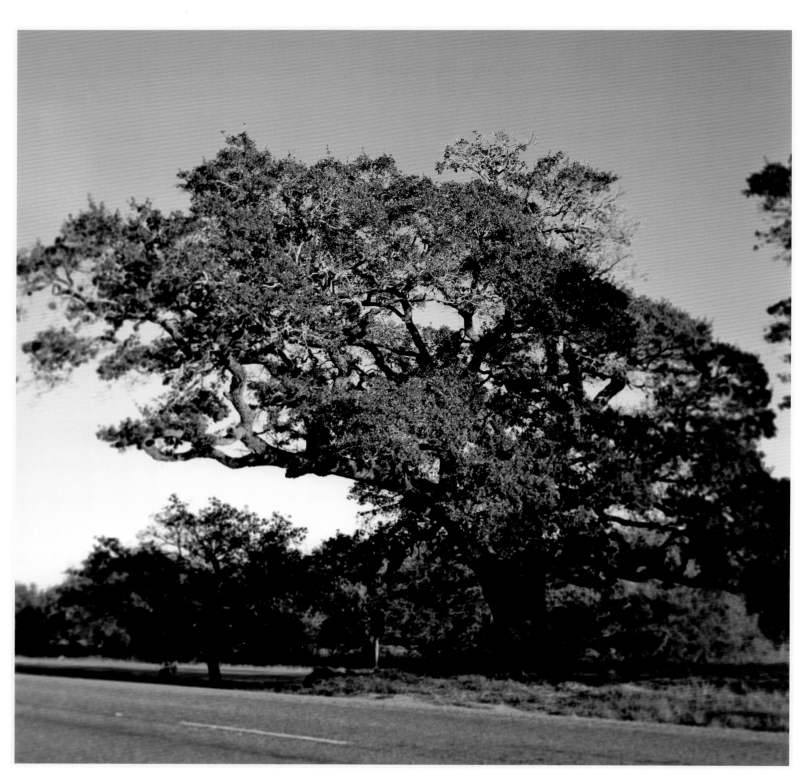

THE URREA OAKS

REFUGIO

❧ You may have passed a place where a vengeful army once paused.

In March 1836, a Mexican army under General Urrea was sent to capture Texan forces fortified in the mission at Refugio. While the well-armed Mexican force camped under a group of huge oak trees, the terrified colonists fled from the mission, leaving behind a small number of people without transportation. A detachment was sent out from Goliad to rescue the stranded colonists. Mexican forces intercepted the rescue party as it forded a stream outside the mission. The hapless Texan relief force was caught in the open with water-soaked powder, so the troops quickly surrendered. Every member of the relief party was put to death.

From the Mission Anaqua, it is only another mile to the Urrea Oaks. From Our Lady of Refuge Church (1008 South Alamo Street/ US Highway 77) in Refugio, continue to the southwest on US Highway 77. The trees are in the highway median between the lanes of traffic.

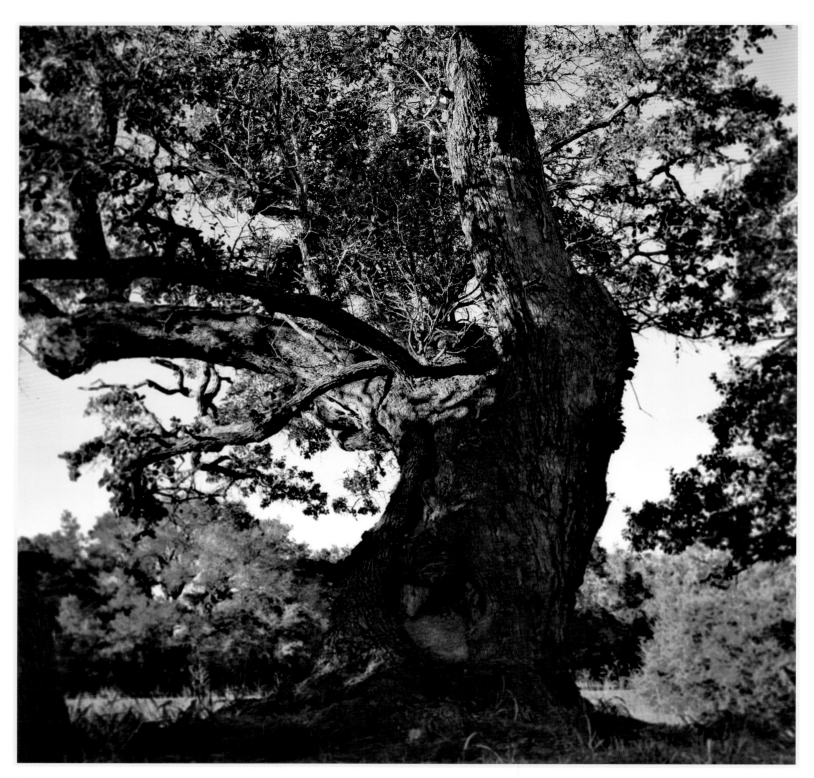

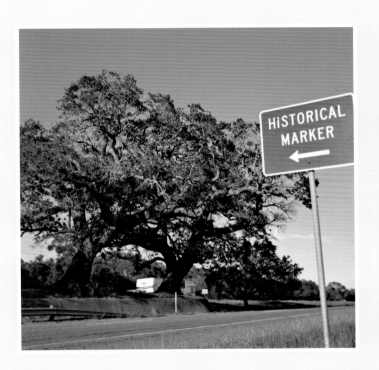 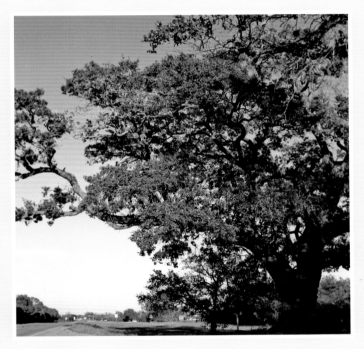

According to the plaque beneath the Urrea Oaks, "By tradition, camping place in March, 1836, during Texas war for independence, of Gen. Jose Urrea of Mexico. Strategically located, this was Urrea's staging area. Capt. Amon B. King came from Goliad with his Texas volunteers to support the Refugio townsmen who were taken into the safety of Mission Nuestra Senora Del Refugio. Then Lt. Col. William Ward also arrived on March 13, and the 'Battle of Refugio' began. Both King and Ward left protection of the mission, and Urrea won final victories over them, capturing King's command on March 15 and Ward's on March 22."

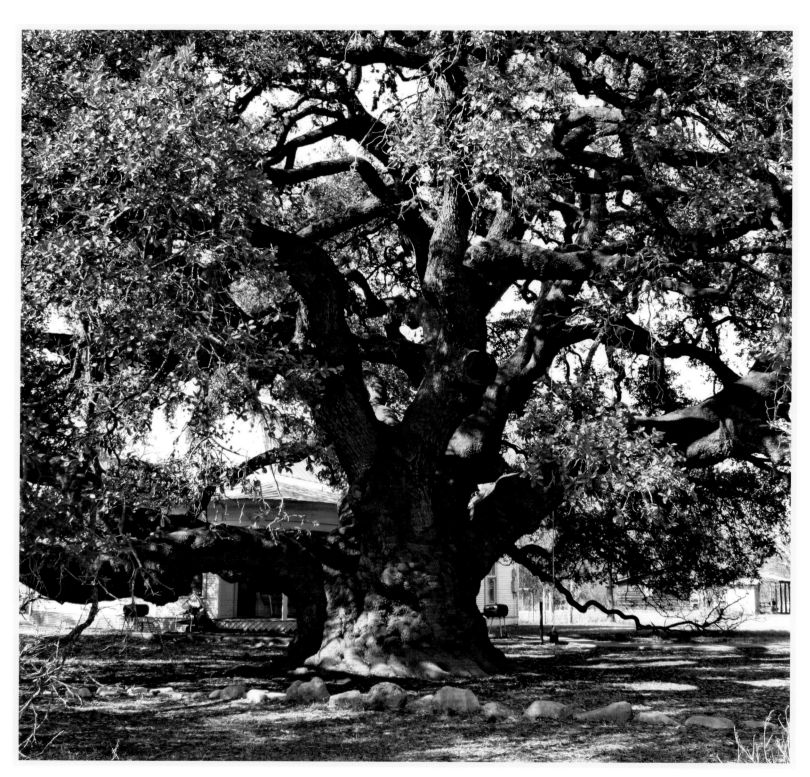

THE RIO FRIO LANDMARK

RIO FRIO

After providing illumination in the wilderness, it fittingly served as a place for learning.

Nestled deep in the Hill Country stands a mighty oak tree that served as a landmark and shelter for early pioneers. For unknown centuries, travelers used this enormous tree to help them get their bearings. The remoteness of the location finally gave way to civilization around 1866 in the form of a tiny settlement that grew up while an irrigation ditch was being excavated in the area. Soon, a school, the Lombardy Academy, sprang up in the shadow of the great tree, and students used the tree for shelter and play. The school and the tree were also used for parties, church services, weddings, elections, and court sessions. When a townsite was finally laid out, the tree served as the bearing point for the original town plat. The memories of the old school have faded, but the gargantuan tree remains as a living memorial to humankind's desire to bring civilization to remote places.

Rio Frio is west of San Antonio and lies midway between Uvalde to the south and Leakey to the north, near US Highway 83. To find the tree, take Ranch Road 1120 from US Highway 83, and proceed east about a mile and a half to the town of Rio Frio. The tree is on private property on the left, but a Texas historical marker can be viewed by the side of the road.

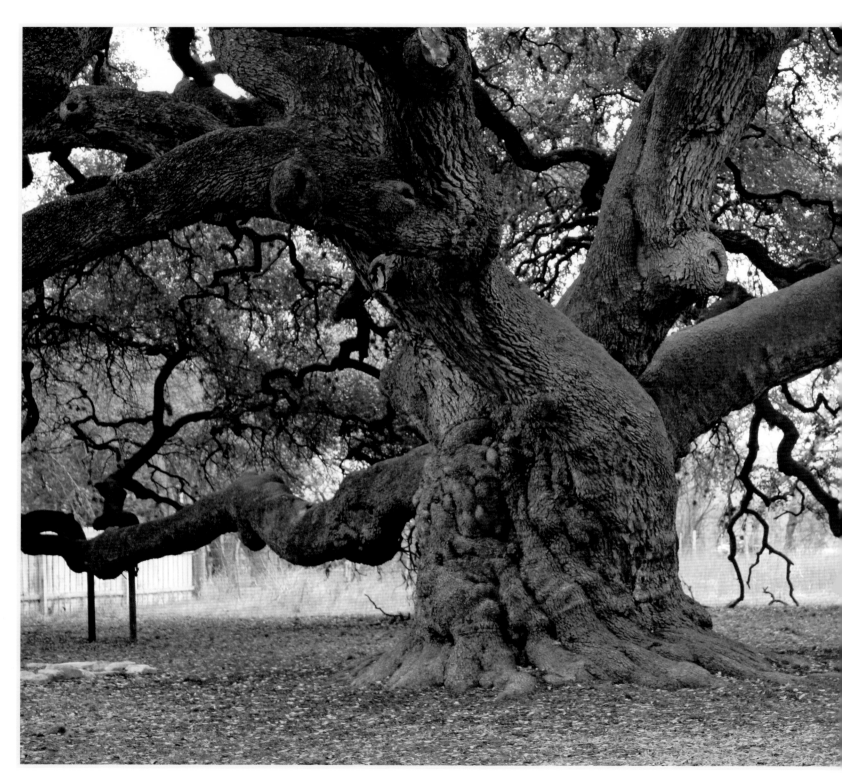

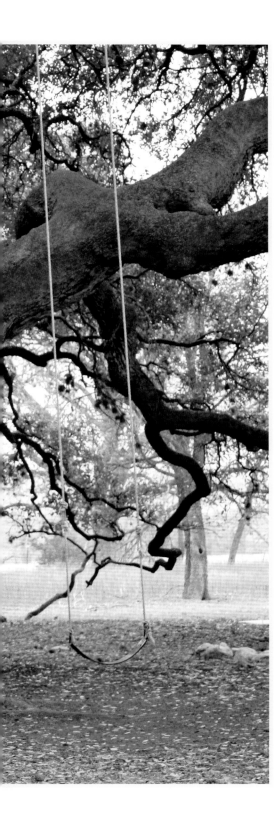

According to plaques erected near the Rio Frio Land-mark, "Through countless centuries, this tree's enormous branches have provided shade and shelter for many people. With our loving care, it will be part of our future," and, "This tree has been listed as a champion in the American Forestry Association National Register of Big Trees."

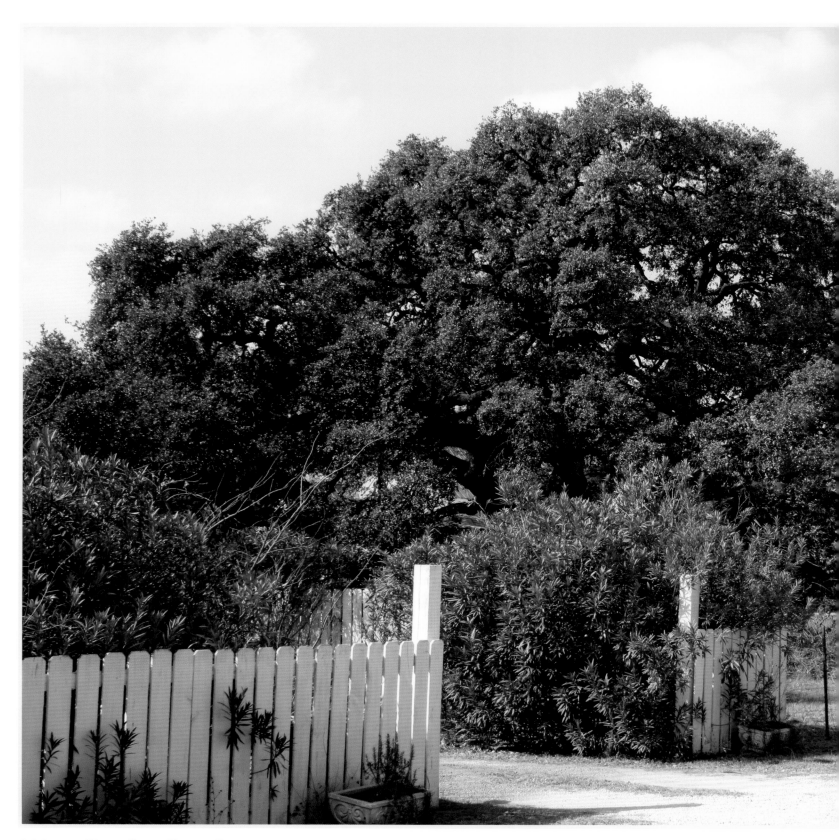

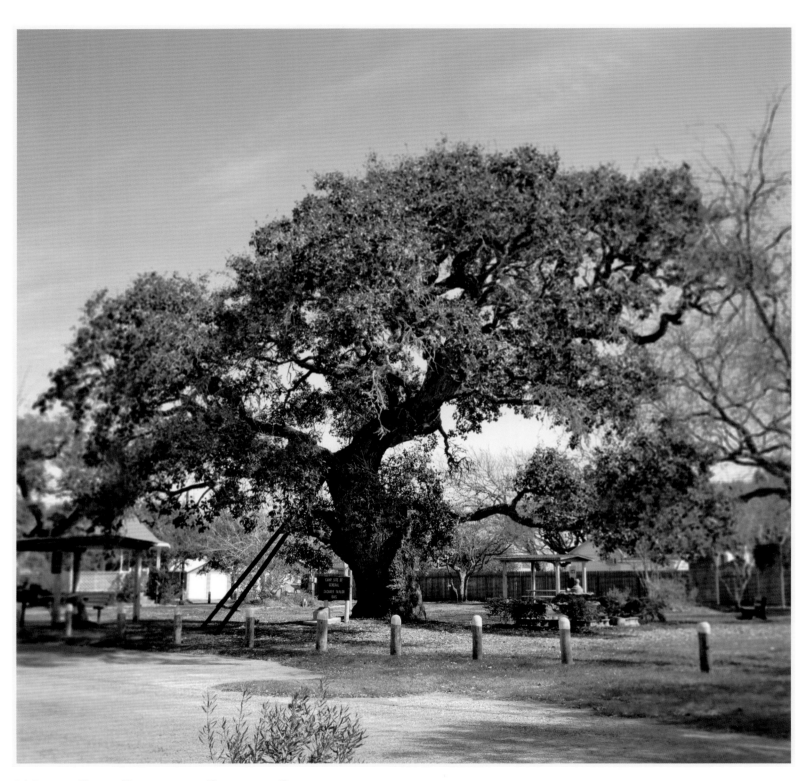

THE ZACHARY TAYLOR OAK

ROCKPORT

When the first American soldiers in Texas needed shelter, a tree served its country.

As the United States and the Republic of Texas negotiated the latter's annexation in 1845, the federal government ordered Brigadier General Zachary Taylor and several companies of the Third Infantry to proceed to Texas, await the formal annexation, and be on the lookout for Mexican troops that might cross the border to prevent the long-feared annexation. Just north of Aransas Bay, three of General Taylor's companies boarded a small boat and headed for the mainland, only to run aground. After the operators of fishing boats in the area took the soldiers ashore, the men camped beneath a massive oak tree situated where the town of Rockport is today.

From State Route 35 just west of Rockport, exit at Farm Road 1069 (West Market Street) and proceed southeastward, passing the intersection of Business Route 35 and proceeding four blocks, to South Pearl Street. Turn south on South Pearl and go one block to East Bay Street. The Zachary Taylor Oak is on the southeast corner of South Pearl and East Bay streets.

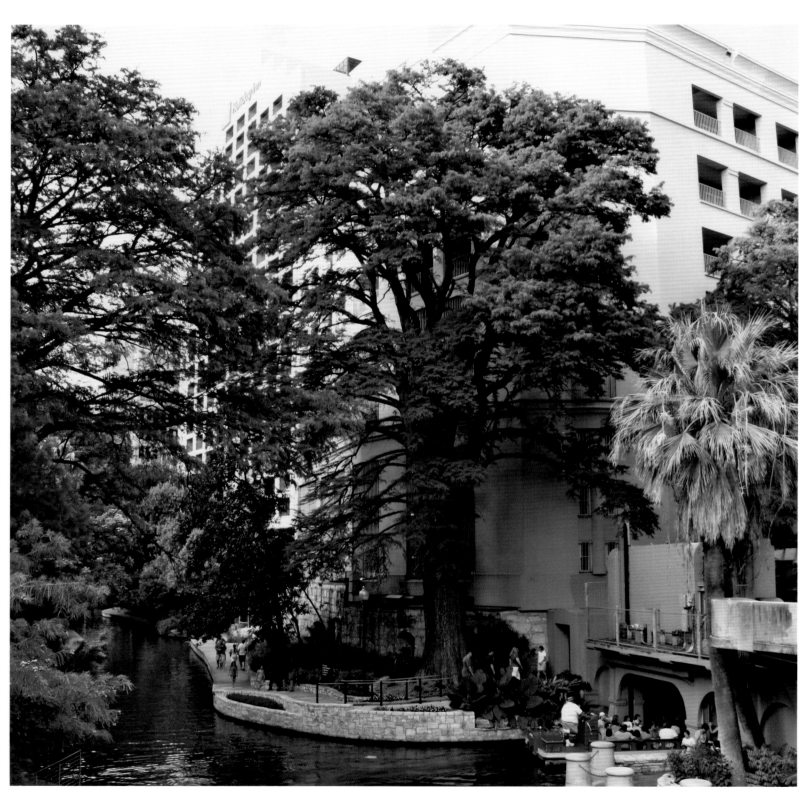

THE BEN MILAM CYPRESS

SAN ANTONIO

✍ From its branches, a sniper's musket sent an early hero straight to a higher place.

Although most people are familiar with the story of the Alamo, many are unaware of the bitter struggle for possession of San Antonio that preceded the famous battle. Late in 1835, the Texas forces were laying siege to the town, then held by a Mexican army. Frustrated at the lack of progress, Ben Milam, one of the unofficial leaders of the Texian army, suddenly leaped to his feet and shouted, "Who will follow old Ben Milam into San Antonio?" Roused, the army charged into the city and began a bitter, house-to-house struggle. Early in the battle, Milam was picked off by a Mexican sniper perched high in the branches of a tall cypress tree on the banks of the San Antonio River.

Today the Ben Milam Cypress can be found behind a parking garage at the northeast corner of the confluence of the San Antonio River and the southern terminus of the Riverwalk. From Interstate 37, take the exit(s) for Commerce Street and head west into the downtown district on Commerce. At North St. Mary's Street, follow the stairs down to the Riverwalk, bear right, and you will see the historic tree where the two sections of the river intersect.

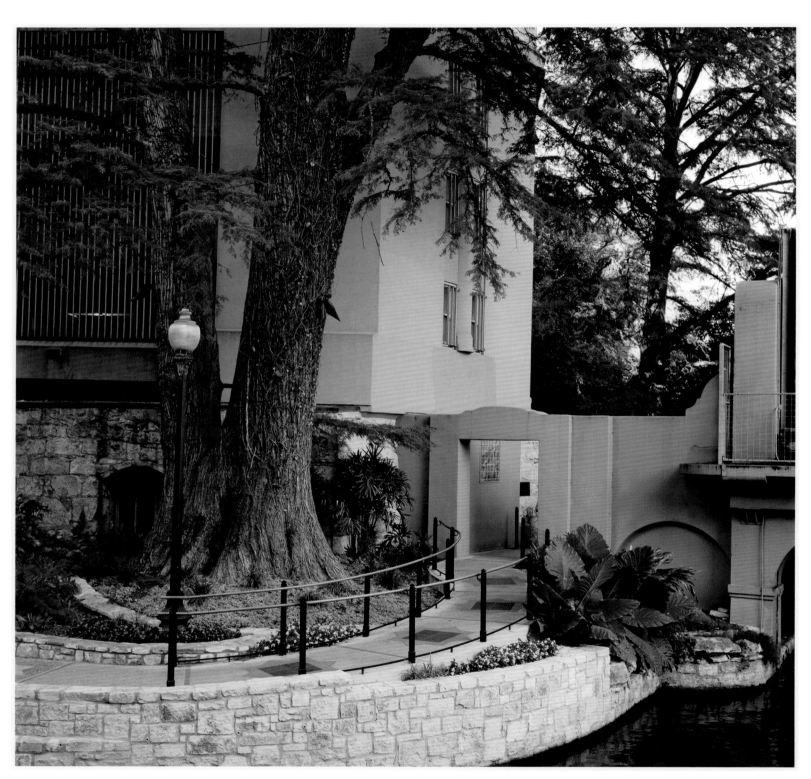

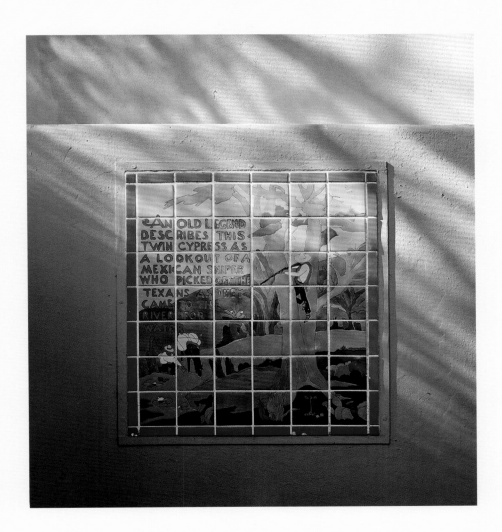

The text visible in the tile mural reads:

AN OLD LEGEND
DESCRIBES THIS
TWIN CYPRESS AS
A LOOKOUT OF A
MEXICAN SNIPER
WHO PICKED OF THE
TEXANS AS THEY
CAME TO THE
RIVER FOR
WATER

The current Riverwalk setting couldn't be more pleasant. Surrounded by the revelers enjoying the pleasant walk beneath the majestic tree, it is hard to imagine the atmosphere reverberating with gunfire and screams and reeking with the smell of gunpowder and death. But the tree stands, a silent reminder of a conflict long ago.

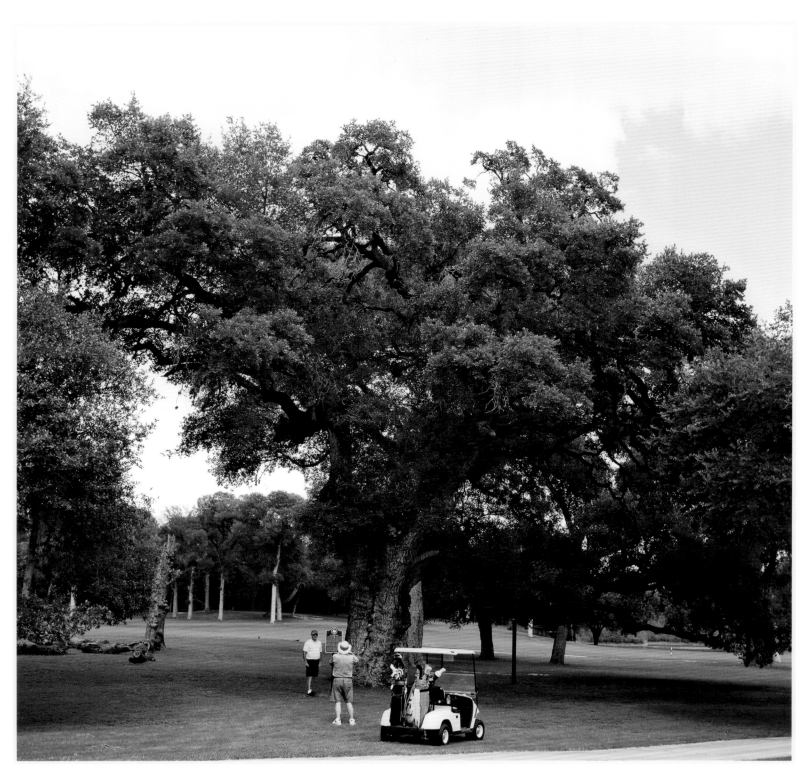

The Burnt Oak

SAN ANTONIO

❧ Witness to historical events, including the 1836 war for independence and the 1968 PGA Championship.

Early in the struggle for independence, the volunteer Texas army camped alongside Salado Creek beneath a towering oak east of San Antonio. From this position, the Texas army moved against the Mexican forces in San Antonio, eventually driving them from the town and setting the stage for the dramatic events that followed at the Alamo. Years later, the campground became the setting for the lovely Pecan Valley Golf Course, which hosted the PGA championship tournament in 1968.

Because the Burnt Oak is located on the grounds of the private golf club, potential visitors should arrange a viewing in advance with the course manager. To reach the Pecan Valley Golf Course, located southeast of downtown San Antonio but inside Loop 410, follow Interstate 37 south from downtown. Take the Southcross Boulevard exit (138-B). Follow the service road, turn under the freeway, and proceed east two miles on Southcross; the club is on the left and the Burnt Oak is near the thirteenth hole tee box.

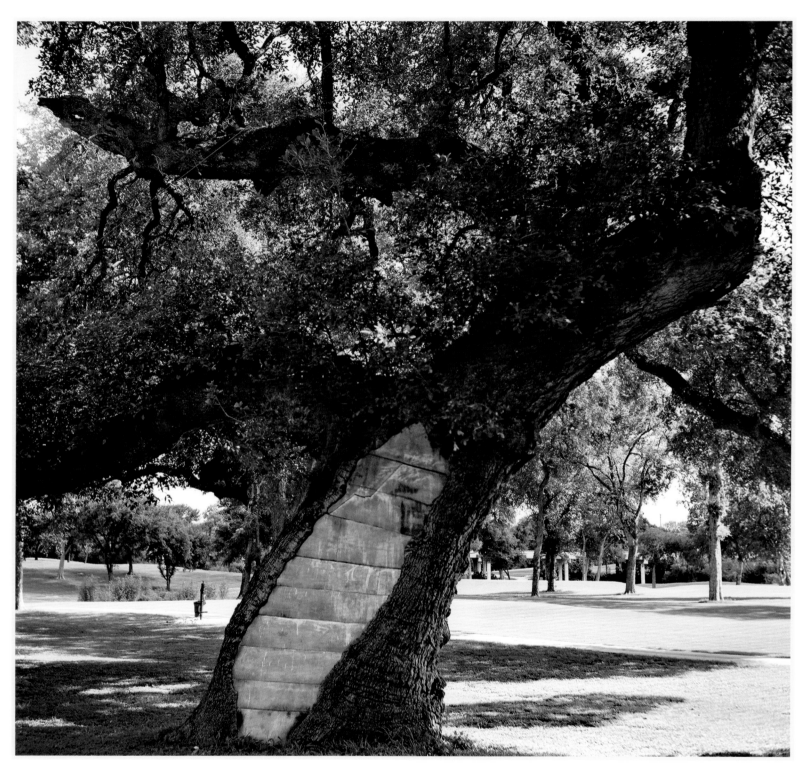

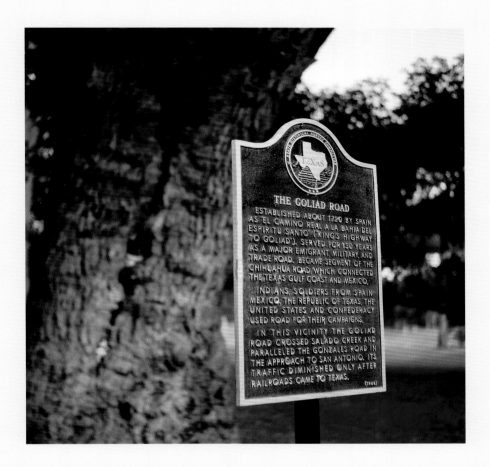

The din of battle and mounted scouts has long been replaced with the swoosh of swinging golf clubs and the whir of electric golf carts. The tree has been sealed with concrete to protect it, giving it a curiously fortress-like appearance. The setting couldn't be more picturesque, and only the towering size of the tree and a plaque detailing the Old Goliad Road hint at a wild history.

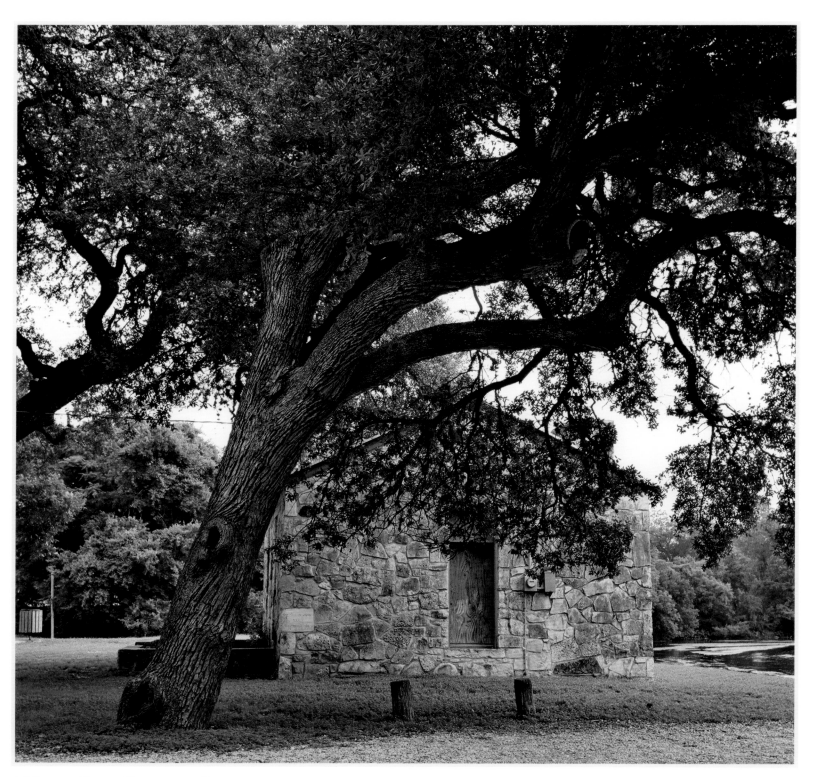

THE KISSING OAK

SAN MARCOS

🐍 Where a Texas hero once kissed his way through a campaign stop.

Along the west bank of the San Marcos River is a small stone cabin. When Sam Houston was campaigning for the governorship of the State of Texas in 1857, he stood under the limbs of this huge oak and spoke to the crowd gathered there. Some of the admiring women present had sewn a Texas flag for him, and he thanked each of them with a kiss. The tree, naturally enough, was soon dubbed the Kissing Oak.

From Interstate 35, take exit 204 and proceed north on Loop 82 (Guadalupe Street) into the downtown historic district of San Marcos. Turn right on Grove and left on LBJ. Proceed north on LBJ to University Drive and turn right. Cross Allen Parkway and enter the parking lot for the River House office of Texas State University. The Kissing Oak is between the Boy Scout Lodge and the old American Legion Post 144.

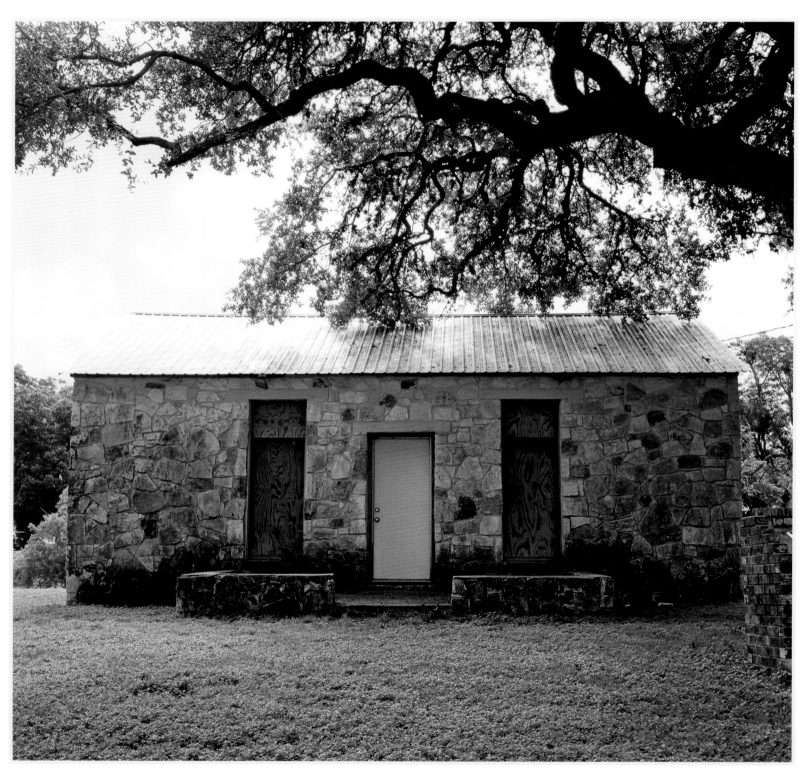

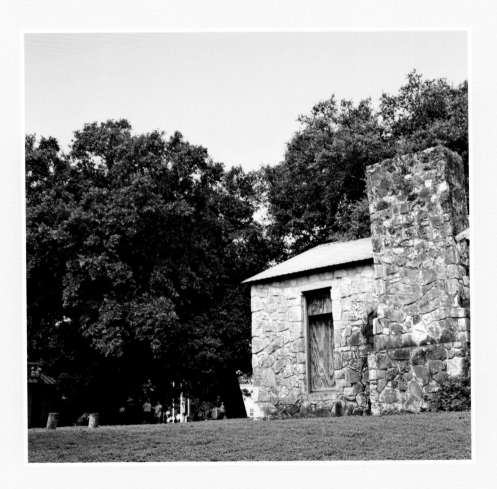

The site has evolved into a lovely park close to Texas State University, which ensures the tree's continued reputation as a place of amorous behavior. An aged stone cabin, appropriately titled the Sam Houston Lodge, sits alongside the tree.

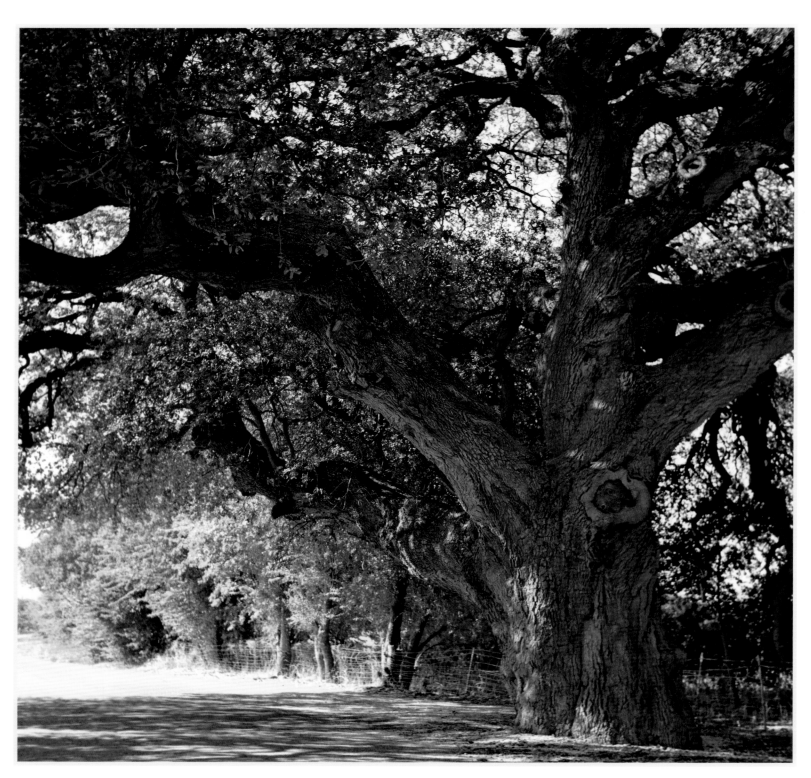

130 THE MATRIMONIAL OAK

THE MATRIMONIAL OAK

SAN SABA

🌿 Lives have become intertwined beneath the embrace of its boughs.

Outside of tiny San Saba in the center of the state, a tall oak sits alongside a narrow country road. It is the Matrimonial Oak, a great tree that legend holds was the site of Native American nuptials. More certain are the Anglo weddings conducted here and documented in the county registry. According to the plaque beside the tree, at least three weddings took place here in December 1911—all on the same day.

San Saba lies at the center of Texas roughly between Waco and San Angelo. To reach the Matrimonial Oak, take US Highway 190 (Wallace Street) west from the intersection of State Route 16 in the downtown area and turn north on Ninth Street. After a short distance, take a left on China Creek Road (County Road 200). After the road curves to the right and you cross the railroad tracks, look for the Matrimonial Oak on the right.

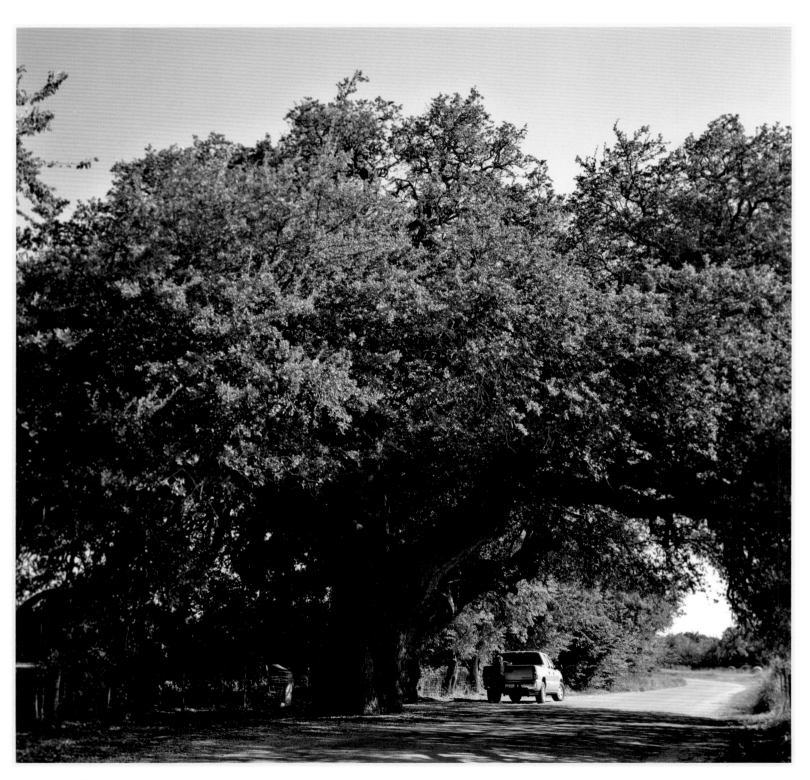

Each of the great limbs is wide enough to constitute a large tree on its own. The soaring expanse easily envelops the road, ensuring that any future nuptials will be well shielded from the elements—except for lightning.

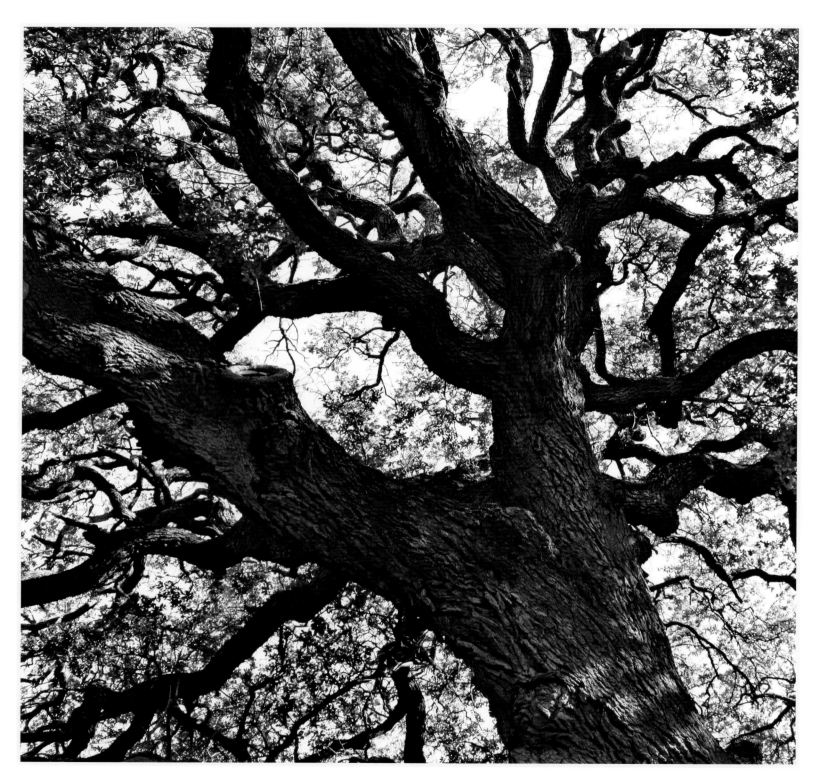

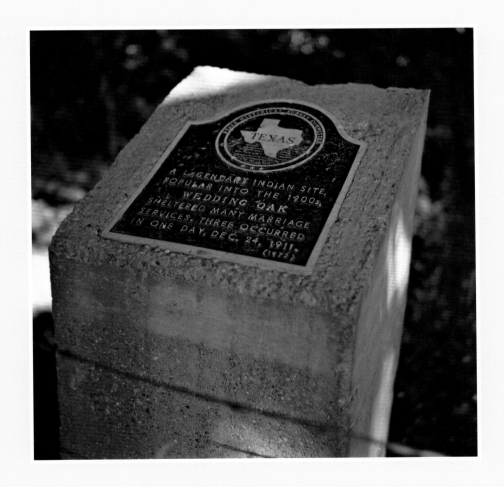

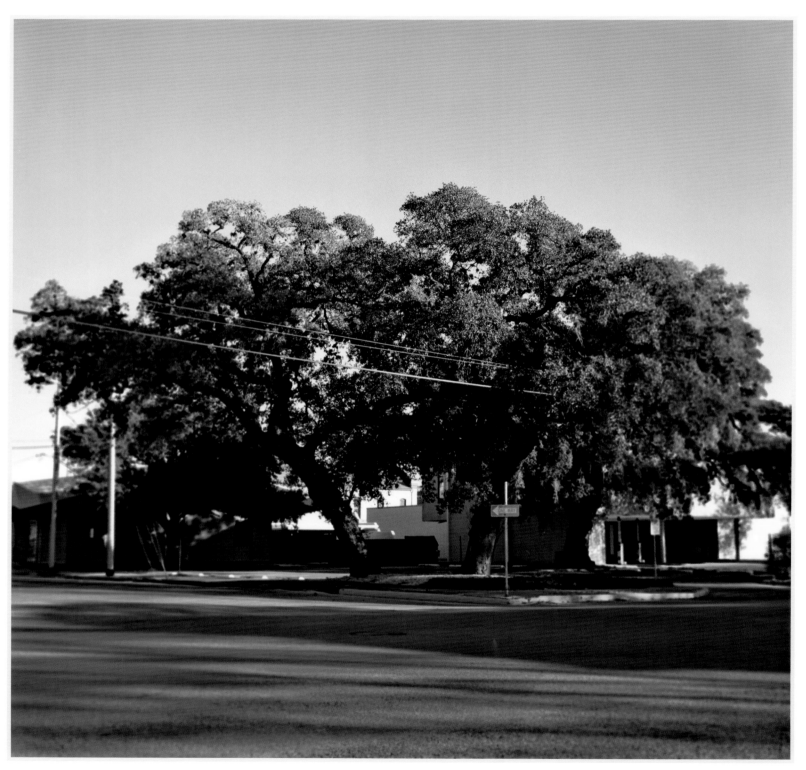

THE RANGER OAKS

SEGUIN

The legendary birthplace of the legendary lawmen.

Long before the town of Seguin was so named, the area was one of the first places where Anglos settled. Here, as early as 1828, pioneers in southeastern Texas were already numerous enough to establish a security force to protect them from Indian raids. By 1834, a group called the Gonzales Rangers would regularly gather beneath a cluster of large oaks and set out in pursuit of the raiders. After Texas became a republic, the Texas Rangers were recognized as the primary law force for the Texas frontier. One of the most famous Rangers was John Coffee Hays, who lived in Seguin. This group of trees in Seguin soon became known as the Ranger Oaks.

The trees occupy a street corner flanked by a bank and the chamber of commerce, two blocks from the lovely town square and the Guadalupe County Courthouse. The town is steeped in history, and stately Victorian homes can be found throughout the area. Appropriately, the trees sit at the intersection of Travis and Gonzales streets, two other names tightly knit into the lore of the Lone Star State.

Seguin lies just off Interstate 10, about twenty-five miles east of San Antonio. From Interstate 10, take exit 609 and turn south on Business Route 123 (Austin Street), heading into downtown. Turn right on West Court Street (US Highway 90 Alt.) and head west two blocks to North Travis Street. Go one block north on Travis to West Gonzales Street, where the Ranger Oaks are located across from a church.

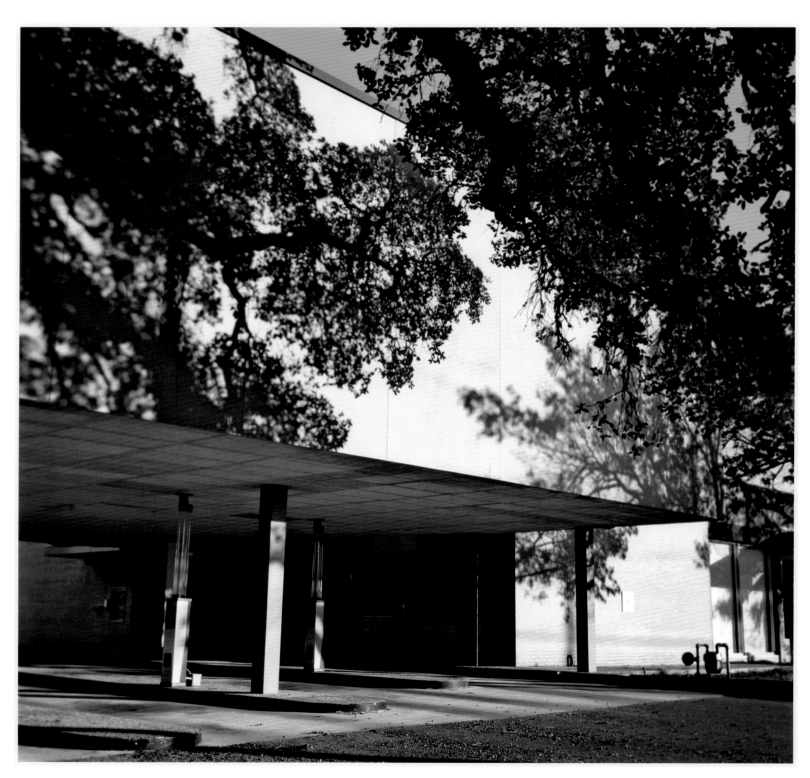

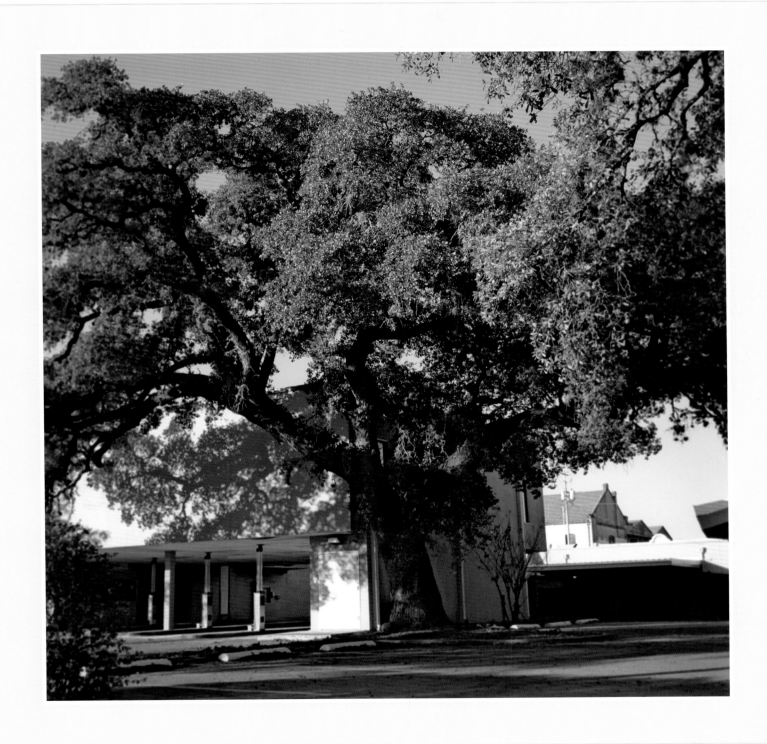

THE WHIPPING OAK

SEGUIN

🌿 The iron hooks embedded in the bark are a painful testament to the frontier past.

The Whipping Oak of Seguin is a reminder that life in frontier Texas was often bitter. County records indicate that the tree served as a site of punishment for many years. Upon sentencing, violators were escorted directly from the courthouse to the tree, where prisoners were manacled to an iron ring in the tree trunk and punishment was swiftly and harshly delivered. One case involved a man who assaulted his wife and earned himself the sentence of fifty lashes.

From Interstate 10 just north of Seguin, take exit 609 and turn south on Business Route 123 (Austin Street), heading into downtown. Cross Court Street (US Highway 90 Alt.) and just beyond the courthouse, turn left (east) on East Donegan Street. Along the north edge of Central Park the Whipping Oak can be seen with its iron ring in the trunk, about five feet above the ground.

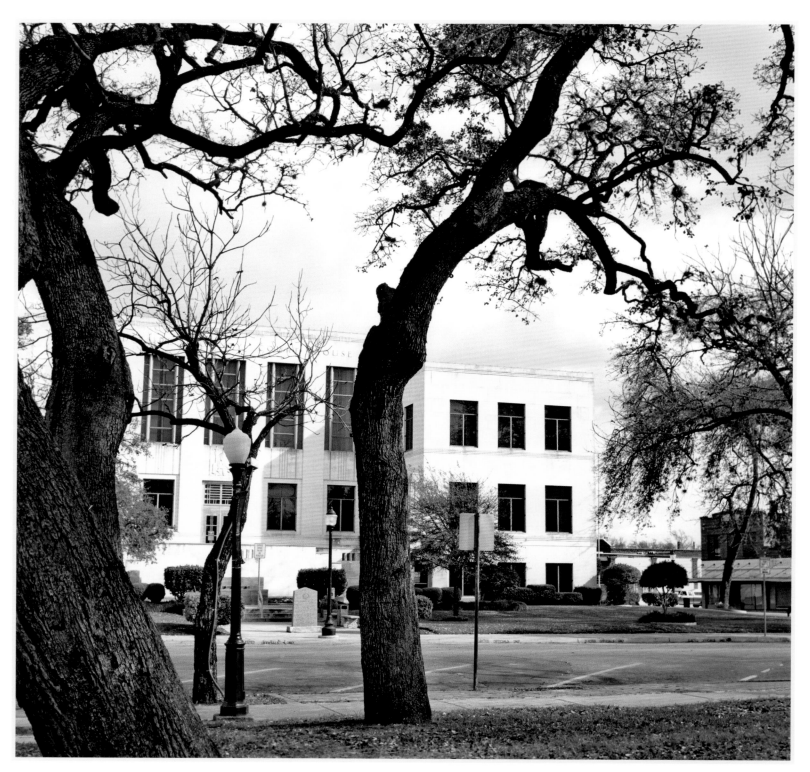

The town square of Seguin is perfectly representative of small towns across Texas, with quaint shops, county offices, and a park square. The peaceful scene provides a striking contrast to the tree and its history of violent punishment. The tree reminds us of a sometimes harsh history and serves notice that justice, while imperfect, has evolved from a difficult past.

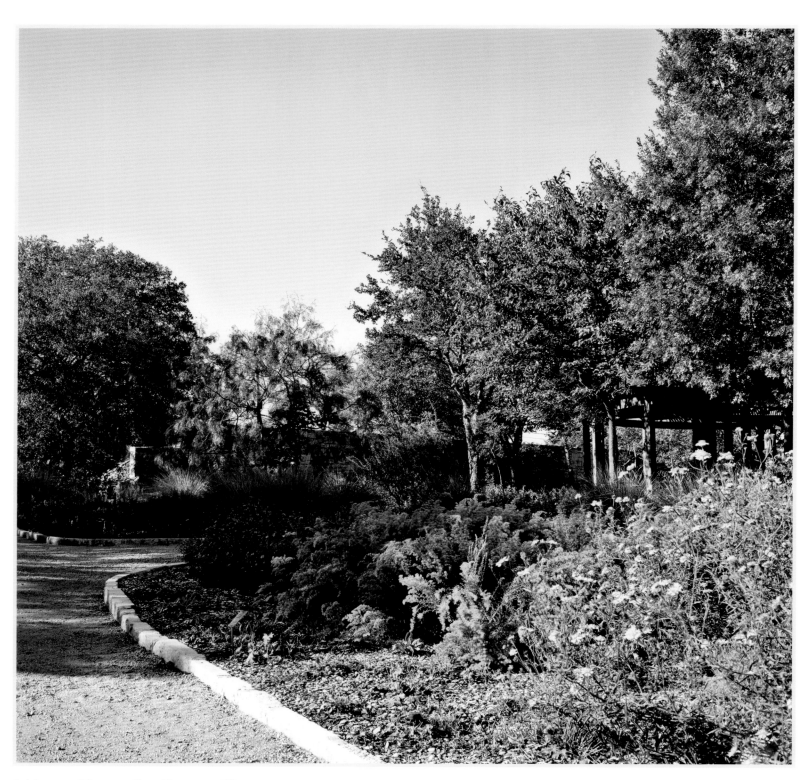

THE HALL OF TEXAS HEROES

AUSTIN

🌿 Where trees renowned for their rich past are propagated and ensured of a lengthy future.

Much planning went into the Arboretum at the Lady Bird Johnson Wildflower Center. This magnificent sixteen-acre area devoted to Texas trees prominently features a planting of famous trees resoundingly titled the Hall of Texas Heroes. Here, grafts taken from several famous parent trees will have a protected place in which to grow anew and thus keep Texas' historic trees alive for many more generations. The Treaty Oak, the Kissing Oak, and the Runaway Scrape Oak are just some of the trees to provide an offshoot, ensuring that future generations of Texans will be able to appreciate their rich past and inspiring them to preserve the natural beauty that is a hallmark of their state.

To reach the Lady Bird Johnson Wildflower Center from the west side of downtown Austin, take Loop 1 South (the Mo-Pac Expressway) past US 290/ State Route 71. Continue south past the traffic light at Slaughter Lane and proceed to the next light, at La Crosse Avenue. Turn left on La Crosse and then head east on Davis for one mile. The Wildflower Center will be on your right. Check in at the gift shop.

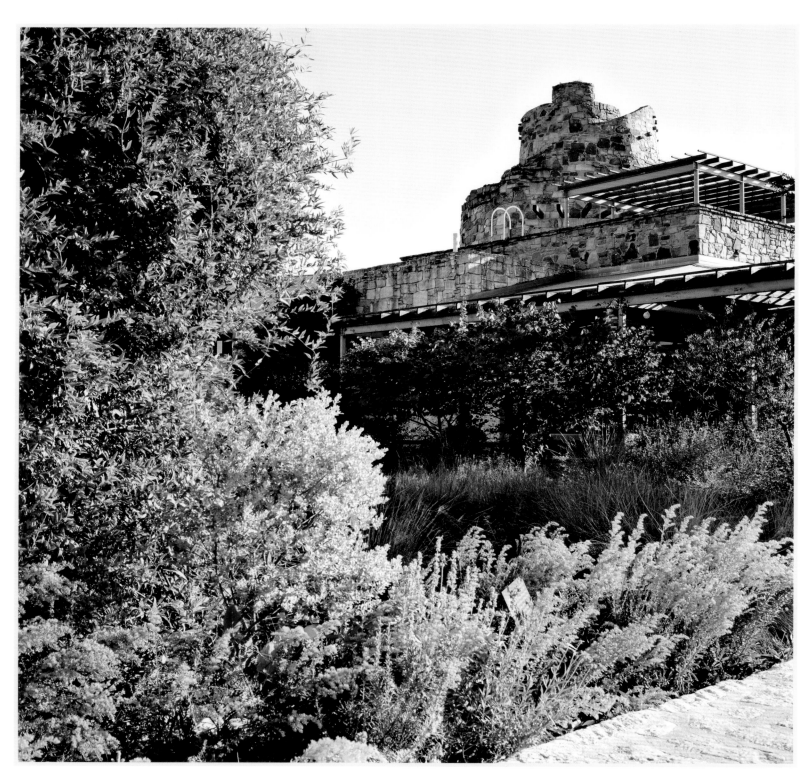

Index